# PROFESSIONAL PHOTOGRAPHY

# PROFESSIONAL PHOTOGRAPHY

## THE NEW GLOBAL LANDSCAPE EXPLAINED

**GRANT SCOTT**

Focal Press
Taylor & Francis Group

NEW YORK AND LONDON

First published 2015
by Focal Press
70 Blanchard Road, Suite 402, Burlington, MA 01803

and by Focal Press
2 Park Square, Milton Park, Abingdon, Oxon OX14 4RN

*Focal Press is an imprint of the Taylor & Francis Group, an informa business*

*Notices*
Knowledge and best practice in this field are constantly changing. As new research and experience broaden our understanding, changes in research methods, professional practices, or medical treatment may become necessary.

Practitioners and researchers must always rely on their own experience and knowledge in evaluating and using any information, methods, compounds, or experiments described herein. In using such information or methods they should be mindful of their own safety and the safety of others, including parties for whom they have a professional responsibility.

Product or corporate names may be trademarks or registered trademarks, and are used only for identification and explanation without intent to infringe.

*Library of Congress Cataloguing in Publication Data*
Scott, Grant, author.
Professional photography : the new global landscape explained / by Grant Scott.
pages cm
1. Photography–Digital techniques. 2. Photography–Vocational guidance. I. Title.
TR267.S386 2015
771–dc23
2013050908

ISBN: 978-0-415-71754-0 (pbk)
ISBN: 978-1-315-87128-8 (ebk)

Typeset in Akzidenz Grotesk and Franklin Gothic by
Servis Filmsetting Ltd, Stockport Cheshire
Printed and bound in China by 1010 Printing International Ltd.

# Bound to Create

You are a creator.

Whatever your form of expression — photography, filmmaking, animation, games, audio, media communication, web design, or theatre — you simply want to create without limitation. Bound by nothing except your own creativity and determination.

Focal Press can help.

For over 75 years Focal has published books that support your creative goals. Our founder, Andor Kraszna-Krausz, established Focal in 1938 so you could have access to leading-edge expert knowledge, techniques, and tools that allow you to create without constraint. We strive to create exceptional, engaging, and practical content that helps you master your passion.

Focal Press and you.

Bound to create.

We'd love to hear how we've helped
you create. Share your experience:
**www.focalpress.com/boundtocreate**

For Samantha, Alice, Daisy, Florence, Penny, and Scottie
for their continued support and patience.

# CONTENTS

P 56

# CHAPTER 3
# GETTING ON-TRACK ONLINE

——

# INTRODUCTION

**I BEGAN WORKING WITH PROFESSIONAL PHOTOGRAPHERS** and professional photography on January 6, 1986. As a first year student studying graphic design at St. Martin's School of Art in London, I had secured myself a two-week internship at the recently launched *Elle* magazine. Those two weeks did not end until 1991, when as the art director I left to begin work in the hallowed corridors of Vogue House at *Tatler* magazine. Those formative early years at *Elle* were a time of knives and glue—which was how magazines were constructed before the computer—well staffed teams, copious advertising revenue, and generous photographic budgets. Communication was by phone or fax—although this was seen as something that was only used for inter-office contact and telephone answer machines were yet to be commonplace—photographers had their own studios and work was national at best, often regional, rarely international. Photographers could reasonably expect their phones to ring regularly, and their workbooks were often full weeks into the future, as long lunches with regular clients and the occasional well-chosen thank you gift ensured both long-standing friendships and regular commissions. The chain of approval for completed work was short and simple and both sides of the industry, photographer and client, were content with the status quo.

Photographers relied on a personally chosen stable of trades to allow them to be photographers. Printers, retouchers, assistants, agents, studio managers, accountants, and bookkeepers all played their part in ensuring that the professional photographer could concentrate on their chosen trade and their defined skill set. There was very little need for personal marketing as it was both a small and open world: a phone call would secure a one-to-one meeting with the person you wanted to see. A commission may not come from an initial meeting but a friendship was often struck and a state of unofficial mentoring would often begin, resulting in a commission or personal recommendation at some stage in the future. Established photographers built client bases slowly and with care, while young photographers gained valuable experience as assistants, and essential knowledge from those who commissioned and who were willing to share knowledge with those they may work with in the future.

Please do not misunderstand me; I am not in any way suggesting that the past was a photographic utopia. It was not, but as with so many creative industries, it was a period in which time was allowed for growth and a generally recognized way of earning a living as a photographer—evolved throughout the previous century—was both established and accepted. More importantly from the perspective of the professional photographer there was a tried and tested path to follow, which if followed with dedication and commitment would, could, or should result in a career as a professional photographer.

Now twenty-seven years later I can clearly see and state that the old road has been ripped up and replaced by an entire network of possible routes with few, if any, signposts. The professional photographer needs a new compass and a new set of skills with which to navigate the many paths that will deliver the career that once offered a single direction.

During those twenty-seven years I have personally worked as an art director, photographer, curator, writer, editor, journalist, creative director, broadcaster, filmmaker, lecturer, and publisher but at all times I have been directly connected to the world of professional photography. Throughout all of these roles I have found myself developing transferable skills—often as a result of the digital revolution—that have turned our industry from one defined by knives and glue to one defined by digital code. It is these skills combined with an understanding of the new landscape of professional photography that I believe are the foundations to a career as a professional photographer in the twenty-first century.

# THE NEW GLOBAL LANDSCAPE

**DESPITE A CAREER DOMINATED BY PHOTOGRAPHY,** I can safely say with my hand on my heart that I had never purchased a photography magazine. So when I accepted the position of editor of *Professional Photographer*, I was placing my head firmly into the lion's mouth. Technique and equipment have always informed my work but have never dominated it, so the creators of these bastions of the "technophile" and "technique geek" were eager to question an outsider like me as to what I would do with the magazine as it stood. The first question I was regularly and persistently asked was, "What do you think defines a professional photographer?" It's a good question, and in the world in which we now live—where anyone who owns a smart phone has the possibility to create high quality images—it is extremely relevant. It wasn't a question that I rushed to answer, but after time and consideration I came to the conclusion that the most accurate and appropriate answer required that I divide the world of professional photography into three distinct areas.

The first is the *high-end professional* who works with a cross section of professional clients within one or across a wide spectrum of photographic genres. They are defined by a high quality client base, which in turn results in a strong financial reward for their work. The second is the *general professional* who also works with a cross section of professional clients within one or across a wide spectrum of photographic genres. They have a slightly less prestigious client base and therefore receive a lesser financial reward for their work. The general professional aspires to be a high-end professional. They usually come from a creative academic background and are informed by the work of their peers. Both of these areas are focused on creating, keeping, and enlarging their commercial client base. The third area is the *domestic professional.* They do not work for professional clients whose job it is to commission photography, but rather they work in the wedding, events, and domestic portrait market. This sector is most often self-taught, regionally focused, and dependent on constantly finding new clients, as the clients they have rarely recommission due to the nature of the reasons for their commissions. The domestic professional is an area that also appeals to the semi-professional, as they do not have to always be available for commission and much of the work is weekend based.

These are the three defined areas that broadly explain how I see the world of professional photography and photographers. Each one has different priorities, and each one requires specific industry understanding. However, I believe that there are two determining factors that are essential to the definition of the professional photographer in today's global marketplace across all three of the areas I have outlined.

The first of these is the ability to create narrative through a series of images and within a single image. The second is the art of consistency, the ability to deliver the image or images the client requires time and time again. It is by understanding these definitions and then by building them into their creative practice, so that they are both recognized and understood by existing and potential clients, that the professional photographer can ensure photography is not dismissed as both easy and cheap.

The world of professional photography has both suffered and profited from the digital revolution. It is true to say that established professionals now have to reassess the foundations of their business as clients' demands and expectations change. At the same time, young photographers have to establish themselves quickly and accurately to ensure that they begin with confidence and success within what is now a globally competitive marketplace. There is no longer time to grow: The long lunch has been replaced with the sandwich at the desk, personal mentoring with an automated e-mail response, and the role of an assistant with that of the digital producer. The traditional meeting place of the processing lab has been replaced with the online connections of Twitter, and international competition for commissions has been fired by the ease of photographic representation that the personal website offers. The digital revolution has taken an art form and placed it into the hands of the non-photographer, making the profession an everyday commodity. In short, the world has changed and the professional photographer has to change with it in order to survive.

# HOW AND WHY IS THE NEW LANDSCAPE BEING FORMED?

There are days when a cool breeze can run through a mature and established landscape and other more turbulent days when a hurricane can sweep through that same landscape destroying all before it, laying bare everything that lacks a strong foundation. That hurricane creates a new landscape and new opportunities to build new structures with new materials, new ideas, and new concepts. It is created by a series of conditions and elements coming together at the same time to create an all-powerful and undeniable force for change. We may not want it to happen, and many may suffer from its arrival, but we cannot prevent it—we can only prepare to respond to its impact. The last decade has seen a hurricane drive through the photographic landscape: a digital hurricane that has created a new creative and commercial landscape for the photographer to navigate. This

is *the New Landscape*. The digital hurricane has created a new photographic topography, and a new creative environment is being built. It is a landscape that is being built with the tools of lens-based media and online communication and by the digital natives and open-minded practitioners who are mastering those tools.

It would be a mistake to believe that photographic equipment is the central element of creativity, but the evolution of digital capture and the arrival of specific cameras along with the technological development of digital media platforms are the spine and foundations of the new landscape. These tools are allowing the new landscape to be formed and subsequently populated.

It is easy with the benefit of hindsight to look back at history and recognize turning points that, in the present, seem to mark a point of change. It is often a mistake to do so, but the development of technology allows us to do exactly that: to accurately pinpoint the arrival of a piece of equipment that takes on a cultural as well as a creative significance. From the invention of the Gutenberg Press in the mid-fifteenth century to the launch of the first home computer, the influence of technology on our ability to communicate has been intrinsic to the creative opportunities and social environment that enable us to tell our own stories and interpret those of others.

## THE IMAGE HAS ALWAYS BEEN BOTH MOVING AND STILL

The evolution of the photographic process since its earliest days has seen the medium embrace different formats and present the opportunity to capture color, details, and movement at an ever-increasing level of quality. But despite these technological advancements photography has remained intrinsically a storytelling medium in which little has changed. Although photography was adopted by the masses early in its development, the role of the professional photographer remained exactly that, a profession. To be paid for the images you created was the preserve of the trained, the experienced, and, therefore, the professional. The mastery of light, darkrooms, and film were intrinsic to the process of the professional photographer. Photography came from chemistry and physics; it was not to be approached at a professional level without due consideration. Knowledge of professional photography was gained from hard to find books, the rare exhibition, and personal interaction with fellow photographers. Communication of photographic practice

took place via learned treatise, printed cards, and the printed portfolio. The professional photographer was identified by the populace as: the high street photographer (of which every town had at least one), available for weddings and formal portraits; the news photographer who captured various levels of local criminality, political change, and daily events; the fashion photographer who lived a glamorous lifestyle of models and celebrity, and whose pictures appeared in glossy fashion magazines; the war photographer who risked his/her life in the battle zones of conflict; and the advertising photographer who created images of products to entice us to buy items we never realized we needed.

With the arrival of the digital hurricane this has all changed. Suddenly the promise of professional quality image capture became the so-called unique selling point of every new digital camera rushed onto the photographic retailer's shelves. Photojournalists were some of the first to embrace the expensive, but limited in function, professional digital offerings. Excited by the promise of an increased speed of image transfer and reduced darkroom cost, their employers purchased these cameras for them. However, wary of the loss of quality—which early digital capture suggested—the majority of pros remained true to their analog past and present.

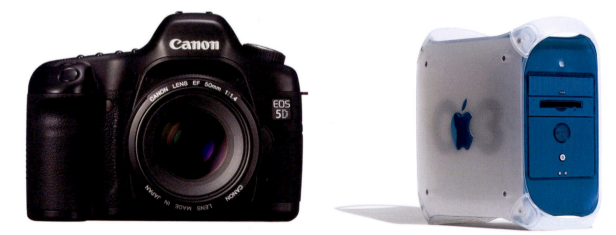

The Canon EOS 5D was the affordable catalyst for the digital capture revolution within professional photography, while the Apple Power Macintosh G3 brought the previously office-based computer into the home. Both are examples of technology transforming every aspect of the creative process.

As the number of megapixels increased, the cost of each new camera model decreased. Then in late 2005 Canon launched the EOS 5D. The 5D was a camera that revolutionized professional photographers' opinions towards digital capture. With its full frame sensor it promised quality at half the price of its only full frame rival, the Canon EOS-1Ds Mark II. Clients were asking for digital images, and the 5D allowed photographers to meet those clients' demands. Those who had previously worked with medium format had to learn a new way of seeing, and the 5D swiftly became a regular addition to any photographic assignment. Canon had done what Apple had previously done with its G3 computer—changed the way creatives thought about and produced images. The 5D had changed the way in which photographers told stories. It had brought democratization to photography by creating a product that could create images of high quality without the skill and training associated with analog film capture and printing. It had put the art of the professional into the hands of the enthusiast.

The world of cinematography—filmmaking—had traveled a similar road since its earliest days at the end of the nineteenth century. Its development was through evolution rather than revolution: first with sound, then color, and then various projection formats, even before the advent of video technology took its place alongside traditional filmmaking practice. These were all important changes for the medium, but filmmaking remained a film-based process throughout all these changes until, as with photography, digital capture became the dominant process. Like photography, filmmaking had been an expensive art form, requiring specialized equipment and knowledge. It was a closed shop to the untrained and financially non-supported, who battled with splice editing, roll up projection screens, and professional processing labs. Today filmmaking and moving image projection are digital processes as they are in photography.

This is where the accuracy of language becomes important. The fact is that the term "filmmaking" is no longer appropriate: film is no longer a factor in the creation of the moving image just as "photography" is an inappropriate term for the capture of the digital still image. (The Collins English Dictionary definition of "photography" is "the process of recording images on sensitized material by the action of light, X-rays, etc., and the chemical processing of this material to produce a print, slide, or cine film." It is not a word that accurately describes digital capture.) We are now in an age in which the capturing of images is defined by digital code, and the only difference between the still and the moving image is the structure of that code.

Perhaps today it would be more accurate to describe ourselves as "image-makers" rather than "photographers" or "filmmakers." However, I find myself having to use these arcane terms until there is a unanimous acceptance of this new terminology for our actual practice. Sometimes images will move, other times they will not. Either way this decision will be made by the image-maker based on their own personal aesthetic—the appropriateness of each format and the story they wish to tell. This concept is at the heart of the new landscape.

The concept of the image-maker may be relatively easy to accept, but a discussion over the use of the terms "video/videographer" and "film/filmmaker" to describe the creation of moving images presents more complex issues that need to be addressed. The use of the word "video" to describe the moving image is inaccurate and yet prevalent. It is a word commonly adopted to differentiate between digital and analog capture by equipment manufacturers and online posting software, as well as to appeal to the mass market that has embraced the idea of video filmmaking as an achievable and affordable endeavor. The frequently used word "film" is also inaccurate, as previously stated. Digital capture

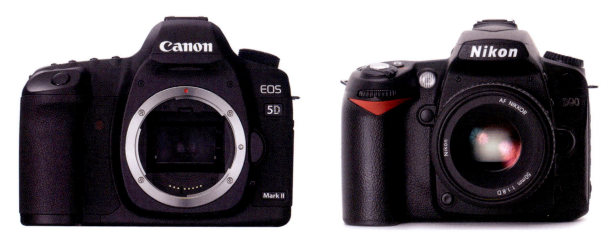

The Canon EOS 5D MKII kick-started the moving image revolution and saw filmmakers adopt a digital single lens reflex (DSLR) for the first time as a filmmaking camera. Excited by the opportunity to access an extensive range of affordable lenses, filmmakers pushed and extended the 5D MKII's functionality far beyond the manufacturer's expectations. The Nikon D90 was the first DSLR to feature moving image functionality, but it suffered from a lack of refinement in its filmmaking capture and was not universally adopted despite a positive response to its launch.

is not film, but the end result is a film—the Oxford English Dictionary defines the word "film" as a story or event recorded by a camera as a set of moving images and shown in a cinema or on a television screen—and is therefore an easily understood term by a film audience. The description of all of this work as "moving image" is accurate but less used, as it requires explanation through historical and technological context. I use the term "moving image" whenever possible to ensure accuracy of understanding. However, I also use the terms "film" and "filmmaker" in my practice and throughout this book as globally understood terms that most accurately describe the final output of the process of creating moving image and those practitioners creating it.

Digital capture has revolutionized the way in which we capture images, but the release of the Canon EOS 5D MK II helped to create the concept of the image-maker. It was not the first DSLR that featured HD video functionality (the Nikon D90 has that honor), but it was the one that the filmmakers embraced and recognized as a piece of equipment that they could use to tell stories at cinema projection quality, which had previously been beyond their budgets, while also opening up a previously unimagined access to photographic lenses.

However, most photographers were slow to grasp the concept of the moving image. Why would they make films? They were photographers, they created still images—even though many had the functionality on their cameras to make films and were just one push of a button away from a new world of experimentation and creativity. The filmmakers had no such reservation and blazed a trail, pushing the camera to its limits and beyond. Just as the Apple G3 and Canon EOS 5D had done, the Canon EOS 5D MK II changed the way in which filmmakers thought creatively. Slowly the photographic community started to understand the opportunities that now lay before them. However, they also realized that they were about to embark on an exciting but challenging learning curve of creative education.

The new opportunities to create digital images, both moving and still, not only changed the photographers' and filmmakers' processes and practices but also changed the photographers' and filmmakers' relationship with their clients. Client expectation grew as commercial budgets shrank, and the creation of images was perceived by the clients' financial departments to be both cheap and easy. This had previously happened to the graphic design community throughout the 1990s as the practice of graphic design became devalued by the arrival of computers in almost every home with simple to use design

programs. Now it is the photographer's turn to feel the rise of the competent enthusiast as the informed professional finds it harder and harder to explain the importance of their practice to potential clients and respond to the new generation of digital natives.

What do I mean by the term "digital native"? Simply, those born into a digital world. Those whose rules of seeing and reference are shaped by their digital experience, and those who have come to photography without knowledge or experience of now archaic practices, practices that are holding back so many previously analog-based photographers. The digital natives are now engaged in building and populating the new landscape.

# THE GLOBAL DIGITAL COMMUNITY

The new landscape is founded upon digital capture and populated by digital natives and early digital adopters, but how is it being built? Just as the early cities of the United States were founded and rapidly built by prospectors, immigrants, and entrepreneurs with little care for rules and regulations, so the new landscape of image-making has had its fair share of badly built buildings, property hustlers, corrupt leaders, dead end streets, and snake oil salesmen. Photography websites quickly became all singing, all dancing design extravaganzas before people remembered that their purpose was to showcase photography, not graphic design or software plug-ins. Photographer blogs became an essential extra until many photographers realized that they had nothing to say and that blogs were extremely hard work to keep going and interesting.

The death of the photographic print was loudly proclaimed until the value of the "artifact" was remembered and reevaluated. The new photographic digital community was and is an interactive community, which is not held back by preconceived concepts of practice or engagement. Whereas in the past the photographic community could have been described as being insular and overly competitive, the new community is reliant on engagement and a mutually supportive attitude.

What has emerged over the past ten years is a digital landscape that presents image-makers with opportunities for communication on a global scale. There are no national boundaries within the new landscape. It is a landscape made up of online communities based around forums, podcasts, social media, crowdfunding (the process of funding a project through online donations from people engaged with your concept), crowd-sourcing (the process of gaining creative and technical help from like-minded profession-als online), live streaming, and blogs, as well as an engaged community based around festivals, talks, debates, seminars, and exhibitions.

Today we have new landscapes of practice and new landscapes of engagement based on technological evolution. We are free to explore these landscapes however we wish or however the client may request. We can explore the possibilities of digital capture; we can mine the history and creative possibilities of analog capture. We can work with soundscapes, the spoken word, the written word, and post-production processes to help tell our stories and respond to our clients' needs. We can share those stories with the world quickly, easily, and cheaply, and we can meet client deadlines globally.

We have passed from a relationship based on the personal face-to-face connection and need of commissioning to a relationship defined by a lack of time (this is invariably due to much smaller commissioning teams and inexperienced or ill-informed commission-ers) and budget. The resulting dialogue is no longer reliant on the commissioned image. Instead clients are sourcing the images they need from a variety of different sources that reduce both financial and creative risk on their part. This change of engagement and expectation has forced professional photographers to create their own models of practice and engagement, often without help or advice on how to do this from the client. Where once their role was clearly laid out for them by the client, photographers are now able to make their own rules and create their own opportunities. This is particularly true within the editorial and advertising environments.

It is intrinsic to human nature to want a set of answers or rules by which to live. Photogra-phers and photographic practice is no different, but the new landscape has no rules, offering instead the possibility of interpretation. This can create a feeling of confusion, doubt, and concern.

The new global online photographic community is open and supportive with little sense of hierarchy, but it does have a number of people acting as touch points on new thought, theory, and work. These include Andy Adams, founder of FlakPhoto.com; award-winning photographer and DSLR filmmaking pioneer, Vincent I LaFloret; theorist JM Colberg, founder of *Conscientious*; the *Duckrabbit* blog; and *aPhotoEditor* founder and former magazine photo editor, Rob Haggart.

# Andy Adams

Digital geek • Photo editor • Movie buff • Jazz fan

👍 ➕ ➡ Email Me

Hello! I'm Andy — I'm a digital producer + photo editor and I'm passionate about images and ideas. For the past 10 years, I've worked with cultural institutions that use the Internet to engage with web-based audiences. Currently, I direct digital communications at Overture Center for the Arts, a Wisconsin-based arts venue that presents a wide variety of performances, exhibitions, and educational programs.

I also publish **FlakPhoto.com**, a website that promotes the work of contemporary artists, curators, and bookmakers to a global audience of people who love photography. I'm fascinated with the Web's potential to inspire communities and frequently speak about internet photo culture at festivals, conferences, and art schools. My lectures focus on 21st century image-making and the opportunities that social media provide creatives to connect with their audiences and each other online.

VINCENT | LAFORET

**Blog**

## Posting a Huge Update to the blog's "Gear Page" for 2014

November 27th, 2013 in Articles / Big Announcements / Cool Stuff / Gadgets / Hardware / MoVI / Photography / Workflow

4 Comments »

🔄 Translate | 🇫🇷 🇪🇸 🇩🇪 🀄 After more than 13 million visits in 5 years to this blog, the site's top landing spot has been the "Gear Page."

I was one of the first to put one of these sections up in the HDSLR world 4+ years ago, and oh my, how times (and gear!) have changed.   The original intent of the section was to try to create a good resource that would help answer the hundreds of e-mails I would receive each week from people looking to put together the best kit for their HDSLR kits.

I and several others have put a significant amount of energy into this section and I decided it was time to do a major update – **now with close to 400 items listed (!!!)  that go beyond the HDSLR** world that we now work in and include the new cine-series cameras, lenses, and accessories.

THE **GEAR** PAGE

EDUCATIONAL RESOURCES

ABOUT | ARCHIVES

# About Conscientious Photo Magazine

TINTYPESTUDIO.NL

Conscientious Photography Magazine is a website dedicated to contemporary fine-art photography. It offers profiles of photographers, in-depth interviews, photobook reviews, and general articles about photography and related issues.

Founder and editor Jörg M. Colberg began publishing *Conscientious* in 2002. *American Photo* included Colberg in their list of "Photography Innovators of 2006," writing "a new generation of thought leaders has emerged to give photographers and photography fans new avenues of information."

In addition to working on *Conscientious*, Colberg has contributed articles/essays to magazines and artist monographs (such as Hellen Van Meene's *Tout va disparaître*). He has served on review panels and has reviewed portfolios at various locations.

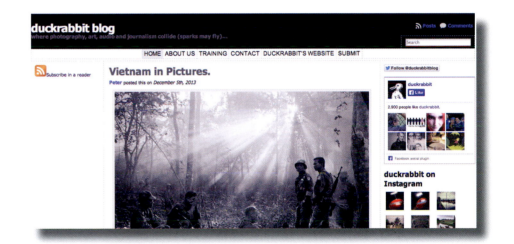

**duckrabbit blog**
where photography, art, audio and journalism collide (sparks may fly)...

Posts | Comments | Search

HOME  ABOUT US  TRAINING  CONTACT  DUCKRABBIT'S WEBSITE  SUBMIT

Subscribe in a reader

## Vietnam in Pictures.

Peter posted this on *December 5th, 2013*

Follow @duckrabbitblog

duckrabbit
Like

2,900 people like duckrabbit.

Facebook social plugin

**duckrabbit on Instagram**

aPhotoEditor

RSS  Twitter  Facebook  g+  Search

" QUOTED "

When people put millions on the table, they want to know what they're getting.

The clients are in a different space today. They don't want to take risks. They want to see the advertising campaign before it is shot. It's not like 10 years ago. That's finished.

# Art Producers Speak: Patrick Ecclesine

Suzanne Sease - December 5, 2013 - Art Producers Speak

Tweet 30 | Like 27

We emailed Art Buyers and Art Producers around the world asking them to submit names of established photographers who were keeping it fresh and up-and-comers who they are keeping their eye on. If you are an Art Buyer/Producer or an Art Director at an agency and want to submit a photographer anonymously for this column email: Suzanne.sease@verizon.net

**Anonymous Art Buyer:** I nominate Patrick Ecclesine. I like working with Patrick because he has a vision that elevates anything I have ever had in my mind when approaching a shoot. He has a bank of knowledge and creativity that allows me obtain more than I anticipated and more concepts and ideas I haven't even thought of.

Visit Our Sponsor

aPhotoFolio

Website Software For Professional Photographers

**RESOURCES**

♦ The Agent List

♦ Photography & Architecture

**ABOUT**

All communities demand leaders and the new landscape of image-making is no different. To meet this basic human need within the greater community, an international inner core of thinkers and practitioners has emerged to explore, practice, process, and share their personal experiences. These spokespeople engage with the community through online platforms such as Twitter and personal blogs. They are the compasses by which the new landscape can be navigated. These are the people who are attempting to chart unknown territory. They come from all areas of creative practice but share an open-minded desire and willingness to question, experiment, engage, and create. They are not setting rules, but they are helping us to question, establish, and set our own parameters of practice.

All art needs to evolve to survive, and photography is no different in this need for evolution. Stagnation of thought and practice negates the personal language of the image-maker. This is the same in all other art forms from painting to sculpture, from dance to drama, from poetry to literature. All visual representation needs to be questioned to ensure growth, for without growth we are nothing more than visual historians. With this understanding the premise of the new landscape of image-making is not only obvious but also essential. Technology has merely been the catalyst and enabler of that landscape.

The digital world is full of noise, and that cacophony of noise makes it hard to be heard. It makes it hard to stand out and make your point, express your opinions, build a client base, and tell your personal stories. Adding to that cacophony without a distinctive voice is therefore pointless. It is better to be quiet while you define what you have to say and how you want to say it. Listen to those who are speaking clearly and observe how they disseminate what they have to say so that it can inform your own language.

The new landscape is there to be explored, but how do we prepare and equip ourselves for our travels? That is the purpose of this book: to prepare and equip you by bringing understanding of the current professional environment, to question your understanding of your role within it, and to provide you with practical advice based on the experience of others engaged in both building and navigating the new landscape.

# WHAT IS THE DNA OF THE TWENTY-FIRST CENTURY PROFESSIONAL PHOTOGRAPHER?

I have mentioned that I have been asked the question, "What do you think defines a professional photographer?" I have also outlined my response in depth. But my own personal journey to discover an answer has led me to ask the same question of others, who I feel have yet to understand how the answer helps to define their personal expectations of a career as a photographer—in this respect I suppose that I am poacher turned gamekeeper. The answers I receive from aspiring photographers and students seem to be universally similar: "You get paid to take photographs." "You work for magazines." "You take the pictures you want and people pay you." Sometimes I am met with a protracted silence that ends with an awkward admission that the person does not know and has never considered questioning what defines them as a photographer.

From experienced photographers the answer is different, but again there is a universal commonality: "Well, it's all changed." "That's a good question. It's not like it used to be." "I don't know anymore." "I still do what I used to do, I just don't shoot as much; but I still describe myself as a professional photographer." This sense of confusion and loss of direction is most obviously stated in a joke, "What is the difference between a deep dish pizza and a professional photographer? A deep dish pizza can feed a family of four!" This is a realistic situation for many photographers, but it does not have to be the case—however, it will be if professionals continue to see themselves purely as providers of still images for commission.

It is clear that the term "professional photographer" needs to be both questioned and redefined to accurately explain the expectations that the commercial world has and to assess what skill sets and attributes are now required. The DNA of the professional photographer has to be rebuilt just as you would rebuild the motherboard of a computer to allow it to perform new and more challenging functions.

Photographer Alec Soth has embraced the concept of the new global landscape and has established a photographic practice that allows him to connect his work and personal projects directly with his online community. He does this by creating everything from self-published posters and journals to T-shirts and books via his publishing company *Little Brown Mushroom.*

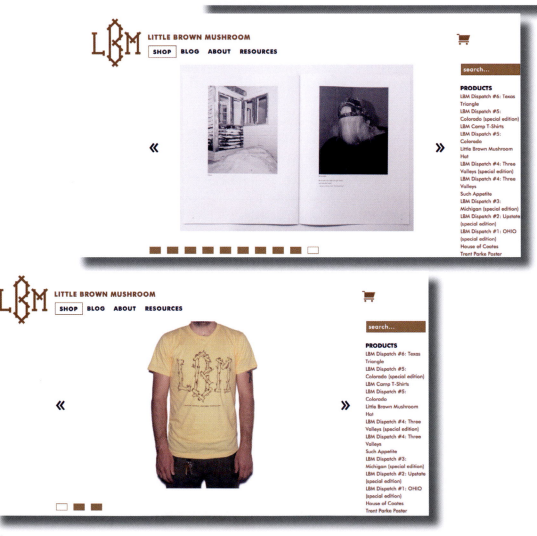

ALEC SOTH

Home
Calendar
Projects
Information
Contact
Links

My name is Alec Soth (rhymes with 'both'). I live in Minnesota. I like to take pictures and make books. I also have a business called Little Brown Mushroom. Right now I'm in Texas.

LITTLE BROWN MUSHROOM
SHOP  BLOG  ABOUT  RESOURCES

search...

PRODUCTS
LBM Dispatch #6: Texas Triangle
LBM Dispatch #5: Colorado (special edition)
LBM Camp T-Shirts
LBM Dispatch #5: Colorado
Little Brown Mushroom Hat
LBM Dispatch #4: Three Valleys (special edition)
LBM Dispatch #4: Three Valleys
Such Appetite
LBM Dispatch #3: Michigan (special edition)
LBM Dispatch #2: Upstate (special edition)
LBM Dispatch #1: OHIO (special edition)
House of Coates
Trent Parke Poster

Today photographers must consider, understand, and be willing to accept that they must also be publishers, marketers, journalists, social media communicators, broadcasters, filmmakers, retouchers, sound recordists, podcasters, bloggers, speakers, post-production artists, typesetters, designers, website builders, distributors, curators, gallerists, promoters, and entrepreneurs. I am not saying that every professional photographer has to adopt all of these roles on a full-time basis alongside their photographic practice. What I am saying is that the new landscape expects photographers to consider all of these roles and will at different times necessitate that they be addressed. Why? Because technology has given photographers the tools not only to create images but also to self-publish, promote, exhibit, and connect their work directly to their chosen audience. It has given them the opportunity to build a community for their work and to communicate with it directly—in short it has put photographers in control and opened up a vast array of creative opportunities that can be used to stand out from the crowd, build a career, and experience creative fulfillment previously available only to those with large budgets and unlimited expertise across all creative fields.

I understand that professional photographers are not necessarily trained journalists, graphic designers, or publishers. However, the moment they decide to create a business card, website, or blog, these are exactly the roles they are adopting. It therefore makes sense to investigate these creative areas and add them to the essential DNA of a professional photographer. The same can be said for all of the other skill sets I have outlined. In addition to curating work on a website, photographers may wish to self-publish their work as a magazine, blog the process, or exhibit their work as a printed show. Photographers may also want to offer clients films for their websites. When you start to see the role of the professional photographer in this context, it becomes clear that the reassessment of your own essential DNA not only needs to be questioned, it needs to be redrawn—no matter what stage of your career you are in.

This redrawing is as relevant to a photographer working within an editorial environment as one working within advertising, from the contemporary art field to the domestic wedding market. All genres of photography require the photographer to understand the fundamental expectation that is being made of them to be able to exist within the new landscape. If you want to earn a living as a photographer in the twenty-first century, you will have to expand your areas of expertise and be open to new areas of learning that you may feel are not connected to your core creative purpose.

We have entered a new century with new possibilities, new challenges, and new expectations. A new global economy and new means of international communication have brought the image to the forefront of multilingual understanding. Photographers should be in the perfect position to place themselves at the center of these developments. However, when everyone is a photographer, it is your responsibility to re-establish your professional credentials. The structure of your photographic DNA is in your hands.

I see this as a golden age for photography and a time full of opportunities. Yet it is also a time of challenges, of which one of the greatest is how to monetize your photographic practice and prevent yourself from becoming a "'busy fool" who fills their days with action without understanding the need for an outcome. There is much to consider within the new landscape and much to understand.

# THE NEW COMMERCIAL ENVIRONMENT

**YOU MAY BE A PROFESSIONAL PHOTOGRAPHER** of long standing or you may be a student looking to make your first tentative steps into the world of photography. If you are the former, you may think that you know the business and that anything you read here is of no relevance to you. If you are the latter, you may have no experience or understanding of the industry. Two extremes of the spectrum. But whichever category you fall within, the following chapter is of equal importance to you.

Professional photography cannot be discussed, embarked upon, engaged with, or understood without first accepting that without a commercial environment, it would not exist. Photography would remain what it is for many—a hobby.

## ALL GENRES OF PROFESSIONAL PHOTOGRAPHY ARE COMMERCIAL

Since its earliest days photography has been used as a commercial venture and the idea of creating and selling images dates from the pioneers of the art form. So it is important not to see commercial photography as either a recent consequence of digital capture or a post-Second World War phenomenon. However, there has always been a creative tension within the world of photography between those who have created images as a form of personal expression with a potential commercial outcome—art photographers or artists—and those who create their images on commission for direct payment—commercial photographers. This tension has been based on the accepted prerequisites for each area of practice.

Artists create pictures for themselves without outside commercial influence, hoping to sell prints through exhibitions, and often as a printed book. Artists' income is dependent on their success at exhibiting themselves as an artist, and creating an atmosphere in which their work is seen as collectable.

Commercial photographers create images as requested by a client. Depending on the amount of creative control they are allowed, they may be able to bring their own interpretation of the client's needs to the final image, but that is rarely a given. Commercial photographers' income is dictated by the client and confirmed before shooting. The opportunity to receive a commission is dependent upon the commercial success of the images photographers create.

When described in terms of their revenue opportunities, artists and commercial photographers don't seem to be very different, and there seems to be little reason for creative or commercial tension. The fact is that however professional photographers perceive themselves they will have to engage with the commercial marketplace.

As I explained in the introduction to this book, the boundaries between specific creative fields have been torn down by the digital revolution. This is also the case within the specific genres of photographic practice. The photographic website is a shop window for photographers to display whatever products they wish to sell, from as many departments they wish to create and populate. Thus, not only does the website allow photographers to promote themselves to a proposed client base but it also allows them to sell prints of their work, to sell self-published books, to promote workshops, and, most importantly, to create an online personality to which existing and potential clients can relate and respond. The website allows photographers to present themselves as multifaceted creatives without preconceived boundaries to that creativity. As long as they have developed a personal visual language and are able to demonstrate a unique way in which they see the world, photographers can cross from artist to commercial photographer as, when, and however they please.

## THE GLOBAL BRAND AND THE CLIENT

In order to talk about the role of the professional photographer in the new global landscape, we must first discuss the role of the client. Professional photographers can now set their own creative agenda but, as has always been the case, it is the client that sets the rules; and the client has been re-writing those rules across a global marketplace since the beginning of this century. The past decade has seen the birth of the global brand, with global ambitions and multiple platform means of communicating brand messages without national frontiers. Clients' online presence and use of social media have resulted in their ability to create personalities for themselves with international impact and international brand message control. To be successful in this market, those brands must have the visually creative content that meets the clients' demands and works across this multiple platform business model.

Retail brands are recognizing the importance of creating their own online communities and communicating directly with those communities via creatively rich and entertaining visual content. The specialist cycling brand Rapha is a perfect example of how a brand can be seen as more than a retail destination online. Rapha has embraced the moving image, live events, and the subject related narrative to ensure that its community return to its platforms on a regular basis even if they are not looking to purchase a product.

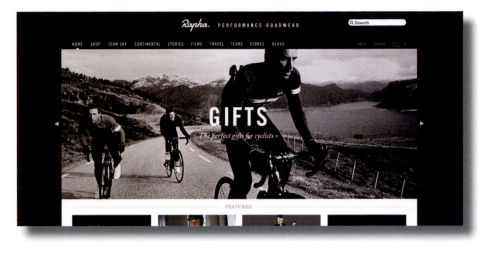

The rise of the brand has not been confined to the international conglomerate. Even the smallest local business has to consider having a website and being active on at least one social media platform, both of which require visual imagery or, as it is most commonly described, "online content."

Of course, businesses have always used images to market and advertise their products—so what's different today? Websites and social media are content hungry. They need to be regularly fed and refreshed to remain vibrant and maintain customer interest. In this respect many businesses have become brand publishers. We have all become used to accessing information, inspiration, and aspiration for free online, to such an extent that brand loyalty is now secured through entertaining content that makes us feel part of the brand's community. Professional photographers are in the perfect position to provide that content, as both still and moving image.

Traditional print publishing—books, magazines, and newspapers—has also been through a period of change over the last decade. The challenge of a global economic crisis impacting on the advertising revenue that all magazines and newspapers depend upon—combined with the availability of free online content—has seen the demise of a number of established titles and a dramatic reduction in the staffing levels and commissioning budgets of those remaining. However, the advent of the mobile smart device has caused many publishers to see the digital magazine as their savior, while others are looking to establish firewall-protected websites. The traditional publishing model is broken: whether or not it can be repaired or rebuilt remains to be seen. While the publishing industry tries to build a new model for itself, it is leaving professional photographers to create their own editorial future.

Photographers need to recognize and understand this new commercial environment and ensure that they can meet the creative demands being made of them. Twenty-first century clients are looking for image-makers to work with them, to understand their brands, to work within their budgets, and to solve problems with visual answers. To some degree this has always been the case; however, an oversupply of photographers and increased economic pressures have produced a new climate of fear and risk aversion. Today, professional photographers are essentially visual problem solvers. The new commercial environment is fast moving, challenging, and demanding. It is a constantly evolving sea of opportunities that photographers have to ride like seasoned surfers to avoid being wiped out.

A selection of home pages created to develop traditional print titles as online offerings. There is also considerable promotion of the titles as Apps, digital magazines, and print subscriptions in order to ensure possible maximum circulation retention or growth.

# A NEW APPROACH TO PUBLISHING AND EDITORIAL CONTENT

In 2000 I found myself within the heart of the "dotcom boom," working as the creative director of a project titled Peoplenews.com. The idea was simple: an interactive, all singing, all dancing online magazine, featuring films, games, and daily updated celebrity news. The team that was to produce this came from the traditional magazine publishing industry and they were full of ideas and creativity, fired by the possibilities that online offered. There were just two problems: no one knew how to build what we wanted; and even if we could build the ambitious site we had in mind, no one would be able to see it, as the dial up broadband capability of the Internet at the time was too slow. Peoplenews.com staggered toward closure, as the "dotcom boom" became "dotcom bust." Money was lost but lessons were learned, and the ambition and creativity was stored until technology had developed to a level that could bring those ideas to fruition.

**The home page for an online publishing portal through which traditional publishers make their offerings available.**

The problem for the world of publishing today is that the technology the industry was waiting for has been made available to all for free, while it was still relying on an old business model. Publishers are no longer the sole gatekeepers of information; as a result their revenues, circulations, and distribution outlets are greatly reduced. Meanwhile, anybody can be a publisher as is evidenced by the 500,000 independent digital magazines published via a single software platform over a four week period in 2013.

So where does that leave photographers who have relied upon the print publishing industry for their income or who want to begin working within an editorial environment? The answer is not simple—but there is an answer. It is based on understanding the changes publishing is going through as I have outlined above. To avoid any confusion as to how photographers should respond, a simple checklist is supplied below.

### How to Respond to The New World of Publishing
▼

1. Understand the client's needs. If the magazine or newspaper has a website, it will require web content, of which the most valuable component is the moving image that I will write about in more depth later on.
2. Understand that you are going to have to work within a small budget.
3. Be a problem solver. Editorial teams are now stretched and often inexperienced. Show your value by making their jobs easier.
4. Provide choice. When money is tight commissioners are afraid of making mistakes without a budget to re-shoot. They may not have the final decision as to whether or not your images are accepted so give them confidence by providing options.
5. Be prepared to hand over your copyright. I am not going to get into the rights or wrongs of this issue or the different national regulations concerning ownership of work. I only want to deal with the reality; and the reality is that the majority of publishers will require you to sign over your image rights. If you don't, you may lose the commission—it's your call.
6. Be prepared to work at short notice with quick turnarounds. Again small teams mean overstretched staff. Because of this the production schedule for many magazines has become extremely compressed. You will be expected to respond to this positively.

7.  Learn as much as you can about the world of publishing, so you can then show that you understand the industry. Being able to show empathy to someone in a difficult position is always a good idea.

8.  Be aware of independent magazines with no budget. This is a difficult area to navigate, as you do not want to devalue yourself as a photographer or be taken advantage of. If you do decide to work in this way, never hand over your copyright.

9.  Clearly define the area of work you create. Only approach publications for which your work is appropriate. This may seem obvious but it is probably the most repeated—and ignored—advice editorial teams give. In today's climate if publishers are not commissioning work like yours, it is very unlikely that they will commission you. In a difficult economic climate risks are rarely taken.

10. Do your research and stay up to date with staff changes. Be certain to obtain the correct name and position of the person you are contacting. The importance of this cannot be overly stressed. This is a basic for any area of business; today editorial teams rarely stay the same for long.

# BRANDS, VIRALS, AND THE NEW WAY OF SELLING

The way in which we purchase has changed so it is only natural to expect that the way in which we are sold products and messages will also have changed. Brands want not only to sell to us but also to have us associate with them, become part of their community, and be brand loyal. This realization of companies' new relationship with their customers has given rise to some incredibly imaginative, sophisticated, and ground-breaking creative. At the same time marketing budgets have contracted. So has the advertising world's desire to take risks and put their clients into commercially untested arenas. This attitude and economic reality combined with the evolution of the super mega-global advertising agency has seen the opportunities for maverick art directors and copywriters decline at an alarming rate. Creative campaigns are now dictated by numeric data, focus groups, and previous returns on investment; not creative, daring, and ground-breaking thinking. The days of the unlimited budget photo shoot are also gone; the account director has now become the final signoff of creative.

A splintering of tasks once completed solely by the advertising agency has shadowed the growth of the mega agency through acquisition and merger. Today brand is the buzz-word, and it is a word repeatedly used by brand consultancies, press relations experts, design groups, digital agencies, and any number of "experts." The result of this splintering is an elongation of the signoff process. Often, from the perspective of the photographer, it requires pleasing a flotilla of people without a clear definition of who is the actual client. Moreover, who actually has the final signoff is an increasingly confusing and creatively restrictive question to answer.

But it is not only photographers who find themselves confused. This confusion also afflicts the various agencies involved with any particular client—each desperately fight-ing to keep the client's account and justify both their fee and inclusion in the creative process. In short the agencies need to ensure that they deliver what they promise, and allowing photographers to control that delivery makes them both nervous and desperate to maintain control. The answer? To use stock images that agencies can show the client within a concept they have developed. The client sees the image, likes the image, and approves the image. Everyone is happy—that is except the photographer hoping to be commissioned. This is not always the case but it is increasingly so with below-the-line work (short-term, cost effective, direct marketing to specific groups), and above-the-line work (advertising that uses mass media platforms such as television, cinema, radio, and print). For proof of what I am saying, just look at the rise to global dominance of Getty Images (see next page for examples).

Which leads me neatly to the world of stock photography. The ability to search, find, and download appropriate images for a client has become the "go to" response when creat-ing client proposals by agency art directors. The client likes the proposal and the image that has been used, so why would they then agree to re-shoot an image they already like, incurring extra cost? From the client's and agency's perspective stock photography meets their needs.

Stock photography provides an outlet for photographers' work with no guaranteed return. It is a numbers game with an element of luck thrown in. The more images photographers have with a stock library the more chance they have of one or two being used. Like craps, you throw the dice and you see if your numbers come up. Of course research into what sells across a wide variety of culturally and socially different marketplaces will always help the odds—the holy grail of stock photography is a new way of showing two people

The growth of the internationally focused stock photo agency focusing on supplying high quality and conceptually sophisticated images has altered the commissioning environment of both above and below-the-line advertising photography.

shaking hands. With the increasing use of stock images—both still and moving—within the new advertising commercial environment, photographers may have to consider shooting stock at some level.

This doesn't have to be at one dollar per sale however. An advertising photographer I know in the UK invests upwards of $40,000 twice a year into conceptual shoots that he creates and then places within his agency to sell to high-end clients. He always recoups his investment and makes a substantial profit, thanks to the quality of his work and his research into client demands and fashions. For him it works, but from my perspective it's still a dice throw, just with higher stakes. If photographers want to play this game, be aware of the dangers of getting it wrong.

This universal approach of "safety first" has had some positive effects on the industry. Primarily in the shape of renegade agencies that have been set up by creatives with something different to offer. These agencies deliberately seek out clients who want to stand out as being different; as far as they are concerned the more rules that are broken the better. As such these agencies are looking for photographers who have a similar approach and mentality. They are looking toward the art world, the online viral, the independent gallery space, and the independent magazines for their talent. They are looking to buy into something that is cool and renegade to sell to their clients, who will in turn appear cool and renegade to their clients. This area offers the most creative freedom for photographers; but also the most risk in getting client acceptance. The client really has to believe in the agency to accept a photographer who is taking risks. One of the ways in which these agencies are gaining that respect is through winning industry awards—the most creative risk-takers are often heralded by the industry even if they are often seen as fringe players. The advertising industry loves awards. If you are being noticed in the same way within the photographic industry, you can certainly expect interest and phone calls to come your way.

As with the world of publishing, the advertising industry has to address the world of digital platforms and social media. Advertising agencies' clients are expecting to be in this new environment and to have the new opportunities to sell their products explained to them by those they are paying to provide the answers. Do they have the answers? They may have some, but in an environment that is changing so rapidly, confirmed campaign success on any new platform can only be guessed at.

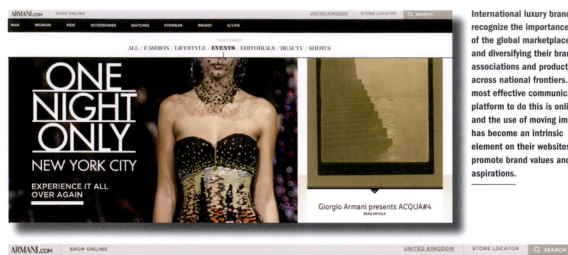

Giorgio Armani presents ACQUA#4
READ ARTICLE

International luxury brands recognize the importance of the global marketplace and diversifying their brand associations and products across national frontiers. The most effective communication platform to do this is online, and the use of moving image has become an intrinsic element on their websites to promote brand values and aspirations.

Armani / Dolci 10th Anniversary
READ ARTICLE

Armani Hotel Milan launch video
READ ARTICLE

So where does this leave the photographer? To a large extent, with a confused and often contradictory environment to navigate. However, it can also be seen as a new landscape filled with opportunities. What do I mean by opportunities? Well I'll give you the example of a photographer I know. His career began in the early nineties, when as a photographer he worked within the music and editorial industries. He then moved to New York and began shooting more and more reportage and general portraits. At this stage he was an editorial photographer who would not be considered for an advertising campaign—after all he wasn't an advertising photographer! Returning to London he continued working as an editorial photographer and began experimenting with the moving image. He created two short films for an editorial client that he then took to show a brand for which he felt the films would be suitable. The client liked them and commissioned the photographer to do more, this led to a film for a fashion brand. He is now making short films for eBay. He is no longer pigeonholed as an editorial photographer, and he does not see himself as either a filmmaker or an advertising photographer—yet he is all of these things. I will talk later in this chapter about the importance of the moving image in a professional photographer's repertoire, but the fact that brands are now taking control of their creative and bringing production in-house is giving photographers the opportunity to deal directly with those who have the final say on how they wish their brand to be portrayed. This removal of the "middleman" creative opens possibilities for professional photographers to bring both their work and personalities directly to the client.

I would say that the new advertising environment could be broadly broken down into three areas: the mega agency, the maverick agency, and the in-house agency, each of which is looking for a different kind of photographer and commissioning experience. It is up to the photographer to decide which works best for them and which is most appropriate for their work. To help make that decision a checklist of points to consider is supplied below.

## How to Respond to The New World of Advertising
▼

1. Decide which type of agency most suits your work and personality before approaching them.
2. Research the commercial stock agencies and see if that is a better option for you to take, rather than a traditional commissioned practice, particularly if your work is concept based.

3.  Be prepared to develop the diplomatic skills of a seasoned politician when it comes to dealing with a multitude of opinions about what the client wants.

4.  Ensure you take professional advice before signing any contracts concerning rights usage across multiple platforms and territories.

5.  If you are not represented by an agent and get a commission that you cannot handle, talk to an agent about handling the shoot for you on a one-off basis. It is better to pay a commission fee and have professional help than have an unhappy client.

6.  Don't agree to handle post-production work unless you are highly skilled in this area. Many agencies now have their own in-house team. Ensure that you discuss who will handle post-production when you are negotiating the budget.

7.  If you are asked to provide moving image alongside the stills ensure that you budget for this separately. If there is no space within the stills budget for moving image ask the client if funds can be found from a different area of the total campaign budget. There is often a contingency that can be utilized, which is not often suggested on commission.

8.  Be prepared for your portfolio to be called in to an agency countless times with no resulting commission. Many agencies call in as many books as possible to impress the client even if they are not appropriate for the commission.

9.  Expect to construct presentations with no fee as a client pitch to a general brief—often in competition with other photographers—without any guarantee of a commission.

10. Be prepared to work tethered and have every frame scrutinized by everyone on the set—and that could run into the high double figures—whatever their photographic experience or knowledge. And never, ever lose your patience or temper with any of them!

## CONTEMPORARY PHOTOGRAPHY IS CONTEMPORARY ART

The argument over photography's status as an art form is as old as photography itself and I do not believe that this is the forum to engage in that complex and often heated debate. Suffice to say that contemporary art photography is big business. How big? This big; Andreas Gursky's *Rhein II* (1999) sold in 2011 for $4,338,500; *Untitled #96 (1981)*, by Cindy Sherman, sold for $3,890,500 also in 2011. Jeff Wall's *Dead Troops Talk*

*(A vision after an ambush of a Red Army patrol, near Moqor, Afghanistan, winter 1986),* created in 1992, sold for $3,666,500 in 2012. Andreas Gursky's *99 Cent II Diptychon* (2001) sold for $3,346,456 in 2007. *The Pond-Moonlight* (1904), by Edward Steichen, sold for $2,928,000 in 2006. *Untitled #153* (1985) is another Cindy Sherman that sold for $2,700,000 in 2010; while *Billy the Kid*, by an unknown photographer, sold for $2,300,000 in 2011. *Tobolsk Kremlin* (2009), by former Russian president Dmitry Medvedev, sold for $1,750,000 in 2010; *Nude*, by Edward Weston, sold for $1,609,000 in 2008; and finally Alfred Stieglitz, *Georgia O'Keeffe (Hands)* (1919) sold for $1,470,000 in 2006. At the time of writing those are the highest value prints sold at auction. Buying and collecting photography is now a global auction staple and the rise of the independent photography gallery and dealer has placed contemporary art photography at the forefront of today's photographic practice.

The influence of the Dusseldorf School on contemporary art photography—thanks to the husband and wife team of photographers and lecturers Bernd and Hilla Becher and their alumni such as Andreas Gursky, Taryn Simon, Wolfgang Tillmans, Thomas Ruff, Candida Höfer, and Thomas Struth among many others—has seen the rebirth of the photographer as a documentarian, a non-judgmental observer, and a recorder of the everyday, of the banal, the obvious. The Dusseldorf School images are created within the form of the "project" or "series," and are heavily contextualized and conceptualized. They are images that look good printed big or in sequence and hung against white gallery walls or within contemporary interiors. They are the staple visual language of this primarily European approach to photography as art—a language that was being developed and explored globally by photographers such as Jeff Wall, Araki, Cindy Sherman, Stephen Shore, and William Eggleston, who have been bringing their own individual aesthetics and interpretation of the photographic image to the gallery and museum table. Photography as art makes big money when sold, and has proven to be a dominant aesthetic within all forms of photography, including commercial, for the past decade. However, it is not the only form of photography that is being readily accepted within the contemporary art world.

It is clear to see from the top ten highest selling prints I have listed that photography which is both collected and highly prized does not always come from the concept focused image-makers of today. Historical prints, unattributed prints, and commissioned commercial prints all have their marketplaces within both the gallery and exhibition environment. This blurring of original context is also evident in the photographers whose

**Photograph has now been embraced by the major auction houses across an international marketplace, resulting in particular images and photographers achieving extremely high prices. This, in turn, has fueled a vigorous culture of contemporary art photography practitioners, exhibitions, galleries, and collectors.**

work is currently sought after and internationally exhibited. A good example of this blur-
ring of the genres is the American photographer, Ryan McGinley. His work for Levi's
has won advertising awards and he regularly shoots still and moving images for fashion
brands; he is regularly courted by high fashion magazines to shoot editorial; he shoots
CD covers; he self-publishes his projects; major publishers publish his monographs; his
work is exhibited in contemporary art galleries; and his prints are internationally sold and
collected. He is a true twenty-first century image-maker whose work has been accepted
by the contemporary art elite; an acceptance that makes him and his work attractive to
the commercial marketplace.

It is this opportunity for photographers to create their own commercial identity with art
market acceptance that is at the heart of the rapid increase in professional photogra-
phers perceiving and describing themselves as artists. Semantics are important to these
photographic artists, as is context. They make pictures, they do not take them—a very
important distinction in today's contemporary photographic environment. This is an envi-
ronment that has built a powerful structure to support itself globally, through festivals,
competitions, workshops, seminars, self-publishing, conferences, and talks. Online,
photographic theory is fiercely debated with self-appointed arbiters of worth, taste, and
quality producing blogs and reviewing, commenting on, and forecasting the future of
photographic practice. The contemporary photographic art world is flourishing and could
easily be described as the most tempting area for young photographers to enter with its
passionate community, promise of self-expression, and potential profit from print sales.
The reality is very different. As with contemporary conceptual art, contemporary photo-
graphic art images and concepts can appear, at a surface level, easy to recreate. This
has led to a decade of work imitating the originators of this visual language without the
understanding and originality of the people whose works achieve the high price. The
market has been swamped with work dependent on an aesthetic to give it context, and
the importance of the personality of the photographer has been lost in a rush to be a
visual observer and not a commentator.

While working within an international auction house I questioned one of the experts
responsible for the setting of the auction estimates for the photography sales. I wanted
to know how they valued any particular image; was it based on the quality of the image
as well as the standing of the photographer and his collectability, as I had presumed?
With the air of an estate agent selling a house he answered my question. Of course, all
of those things were of importance, but the main criteria were: What did the last piece of

work that photographer had in auction sell for? And how big was it? I'm sure that this is not a universal approach to the problem of valuing work but I felt that it was an experience worth sharing with you.

Whatever the dominant aesthetic of the contemporary art market, the twenty-first century is one in which photography has already established itself as an accepted primary art form, and prints from all genres of practice are being purchased by a broad customer base across a wide range of prices. Collecting photographic prints is not, however, confined to the financially comfortable elite. The ease with which photographers can today make their work available for purchase directly through their own websites and self-publishing, which is then marketed via social media, has opened up commercial opportunities for work that may previously have gone unseen. The economic reality of shooting digital has also resulted in many projects being created that previously would have been financially beyond the reach of the professional photographer, without backing or personal hardship. This, of course, has had both a positive and negative effect on the type and quality of work being produced. The democratization of personally motivated image-making can and has resulted in a vast amount of content without content, as well as innovative and experimental storytelling on both a micro and macro level.

The contemporary photographic art market has now been established and is open to all at different entry levels and price points for both the creator and collector. The walls between commercial photographer and artist have been breached, if not completely removed, and the opportunity for professional photographers to add an additional revenue stream to their workflow is now both available and easy to establish. To help photographers understand the basics of getting started as an artist I have compiled the following checklist.

## How to Respond to The New World of Contemporary Art Photography
▼

1. Find your own visual language.
2. Have realistic expectations when pricing your work and decide whether you would rather sell one print at a high price point or multiple images at a lower price point.
3. Research and understand the market of limited editions, closed editions, and unlimited editions, before using these terms to describe your work. Ensure you understand the financial implications of all of these.

4.  Do not exhibit or approach galleries to exhibit until both you and your work are ready to be seen and judged.

5.  Do not expect to make a profit from self-publishing or exhibiting your work. If you do it is a bonus.

6.  Engage with the community to understand how your work sits within the contemporary environment by visiting exhibitions, festivals, and talks.

7.  If you are planning to sell prints ensure that if they are analog that they are correctly processed to be archival; and if they are digital that they are also printed to archival standards.

8.  Building an online community through social media and a personal blog will allow you to have an audience for any projects you wish to sell either in print or book form.

9.  Look to promote your work and in-progress projects through talks at photography festivals. Again, use social media to build a personality for your work and yourself and to encourage festival curators to consider you as a speaker.

10. Be imaginative when it comes to the ways in which you could exhibit your work and where it could be seen.

# GLOBAL PHOTOJOURNALISM: THE RISE OF USER GENERATED CONTENT AND THE CITIZEN JOURNALIST

Approximately thirteen years ago I worked as the art director at the birth of a magazine that went on to be an influential voice in promoting storytelling photography with a con-science—stories that needed to be told, and even more importantly, needed to be heard. The magazine was titled *Foto8* and although it is no longer published in print form it still exists online. At the time photojournalism was fighting for its survival. Photojournalists had lost most of their outlets as the magazine and newspaper industries had turned to lifestyle content to secure much needed advertising revenue and they saw little reason to fill their pages with troubling and upsetting images of conflict and struggle. It was for this reason that *Foto8* was launched; to give a platform for work that didn't have one.

**Foto8 began online before moving into print. It was created to give photojournalists a platform for their work when photojournalism was struggling to establish itself within a new political and commercial environment.**

Photojournalists have found themselves marginalized since the first Iraq War. Governments had learnt their lessons from the media firestorm of images that had come out of Vietnam and Nicaragua in the sixties, early seventies, and eighties. Images that had helped turn public opinion against US involvement. They now recognize the power of the image and are determined to control both creation and distribution of images. In Europe the Serbian-Croatian War provided a dangerous and often critical conflict for photojournalists and reporters to cover, with little desire from the media to showcase the images of grotesque atrocities. To this day very little of the work created during that conflict has been seen. Photojournalists wanting to travel and work without the interference of governments were drawn to the conflicts and wars of West Africa, risking their lives among the warring factions and militias, with no frontlines and little knowledge of who to trust when attempting to gain access to hostile situations. Again incredible work was produced but the outlets in which it could be seen were limited. Photojournalists were risking their lives for very little money, propelled by their sense of conscience and passion to document injustice. To find out about the price some of these photographers paid, I recommend that you read *The Bang, Bang Club*, by Greg Marinovich (Arrow, 2001), about an informal grouping of photographers that included Greg, Ken Oosterbroek, Kevin Carter, and Joao Silva, who covered the township wars in South Africa in the early nineties. Or *Unreasonable Behavior*, the autobiography of Don McCullin, the veteran documenter of so many terrible conflicts and wars.

While photojournalists in areas of conflict risked their lives to tell stories—which they then had to fight to have distributed and sold—the art of the social documentary photographer was also under threat for the same reasons. In the UK and Europe "small" stories, carefully crafted and compiled over a period of years, were also deemed to be not "sexy" or wanted, while in the US newspaper contracted photographers continued to tell their local stories for a local audience. The future did not look good for photojournalism. This all changed with the advent of digital capture.

Photojournalists contracted to newspapers were some of the first professional photographers to embrace digital photography, thanks to their newspapers supplying them with the expensive early cameras. As those early cameras were quickly superseded by more efficient, reliable, and less expensive models the photojournalists were quick to see the possibilities these offered to tell stories and get those stories back to their picture desks quickly. Freed from the shackles of film and processing costs the process of how news photographers delivered their news and how they covered their stories changed. They could explore and expand on the stories they were telling and create award-winning images outside of their news gathering remit. At the same time, thanks to budget airlines and cheap travel, the world had become a lot smaller. Photojournalists could now afford to travel worldwide to find their stories and create them.

The development of the Internet and fast broadband speeds gave photojournalists the platform they had been missing. The planets had collided and photojournalism was reborn. Just as the digital revolution had given art-based photographers the opportunity to express themselves as never before, it also gave photojournalists opportunities to explore one of the oldest crafts, the art of visual storytelling. Young photographers saw the role of the photojournalist as an exciting option, a creative one that was grounded in a sense of the conscious righting of wrongs and bringing light into the dark corners of our world. They were telling the big stories, but also focusing on the small. On the detail of life as well as the grand gesture. They were reclaiming the street, channeling the work of photographers such as Garry Winogrand and Lee Friedlander to create a new genre of photography. As with contemporary art photography, a supportive and sharing structure grew among the photojournalists based online, and through live events such as workshops, festivals, and talks.

Today photojournalism, social documentary, and street photography are powerful forces within the world of professional photography, creating bodies of work of importance and worth.

However, the role of the news photographer has been superseded by a new role for the general public. The first digital cameras were given to the news photographers essentially to cut cost and speed up news delivery. Today with the technological advancements, capability, and functionality of the smart phone, the owner of that phone has become the provider of news content—the citizen journalist has been born. Whether it is a still or moving image, whoever is at the scene can capture the event and deliver it to any news agency globally within minutes, at the touch of a button. This is user generated content (UGC) and it is the future for news gathering operations, television networks, and newspapers with diminishing budgets, readership, and advertising revenue. As newspapers across the world have released their contracted photographers, and long established newspapers across the US have closed, UGC has become the buzzword within newspaper boardrooms and account departments. Its impact on the status and role of the photojournalist cannot be underestimated and has added to the difficulties any photographer faces while creating and sustaining a career within this area of practice. The world of photojournalism is tough to break into and requires commitment, patience, and passion—as do all areas of professional photography—but if you feel that it is an area that you wish to explore, I have compiled a checklist to help you make the right decisions.

### How to Respond to The New World of Photojournalism, Social Documentary, and Street Photography
▼

1. Find and shoot stories that are personal to you.
2. Do not expect stories to come together quickly. They need to be explored, evolved, and developed, and that takes time.
3. Refine your editing skills. A project created over a period of time will inevitably contain multiple images. Defining the narrative through a choice of images requires sophisticated and informed editing skills. Involve fellow professionals in the process.
4. Explore the moving image and audio, as well as stills, to add context and depth to your work.

5.  Consider presenting the finished work across different platforms online, in book form, as a printed portfolio, and in exhibition.

6.  Research others who have created work dealing with subjects similar to yours and ensure that you have your own personal angle to the story.

7.  Engage with the community you are documenting. They are often very approachable and usually willing to look at your work and offer valuable advice and support.

8.  If you hope to syndicate or sell your stories speak to a syndication agency that deals with the type of stories you work on and find out if there are potential clients. It is always better to get this information before you start working on a project so you don't waste time and money than to find out after you have committed both of these.

9.  Entering competitions is a great way to get this kind of work seen. There are a number of well-respected international competitions hosted by associations, such as World Press Photo, www.worldpressphoto.org/contest, and World Photographic Organization, www.worldphoto.org/competitions, that you should research and consider entering.

10. Much of the work created within these areas regularly crosses over into the contemporary art environment so be open to where and how your work is going to be seen and appreciated.

# THE MOVING IMAGE IS HERE TO STAY AND THIS IS WHY

The moving image is the brash newcomer to the world of professional photography and I embraced it just a few months after it made its entrance. As I have previously stated I am not somebody who is obsessed by cameras or technology, but I cannot talk about the importance of the moving image without discussing both.

The Canon EOS 5D was the camera that allowed me to transfer my professional image-making from analog to digital and it is still my "go to" camera of choice. It does everything I need it to and has never let me down. So when Canon launched its successor in the autumn of 2008, the 5D MK II, I was interested.

At the time I was working within a central London auction house that, as an important client to Canon, received some MK IIs in early January 2009. A quick overview revealed a functionality that instantly got me excited: it could make digital films. With no experience of the filmmaking process, I immediately made a digital film of an auction, relying on my knowledge of how a film should look from a lifetime of watching movies. A rudimentary edit in iMovie resulted in a short digital film of acceptable quality, which was shown on a loop, on screens in the auction house's reception area. I was hooked—and excited by the effect the ability to create moving images easily and inexpensively with such high quality would have on the world of photography.

It is worth pointing out that my understanding is Canon had no idea what they were unleashing with the MK II. They had no idea how revolutionary the camera would be when they launched it. Canon perceived the MK II as being an improvement on its predecessor with an added functionality that wedding photographers might like to use. It was down to those within the creative industries—primarily filmmakers—to show Canon the possibilities it opened for the image-making community. Today Canon is fully engaged with that community, but back in 2009 they were taken completely by surprise.

I brought this excitement to my role as editor of *Professional Photographer* magazine when I took over the position in 2009. The moving image is the future, I proclaimed, and we must include it within the magazine by speaking to the pioneer photographers and digital filmmakers who were at the forefront of this new and exciting area of creative practice. My conversation with friends working for clients in the States had confirmed my early suspicions concerning the need for photographers to embrace the moving image, but they were experimenting with the far more expensive and temperamental RED camera. Canon's DSLR had none of the work process issues the RED was showing—although the MK II had its own workflow peculiarities and issues that digital filmmakers were overcoming, thanks to their technical knowledge of the filmmaking process—and it was a fraction of the price. Everything was falling into place and the future was obvious to me and a few others. However, it was not yet clear to either the wider photographic community or the camera manufacturers.

The creation of photographic images is a relatively simple process to understand and since the advent of digital capture it has become as simple as you want it to be. However, filmmaking is not a simple process; it requires expertise in a number of areas including pre-production, editing, scripting, lighting, and audio, not to mention the shooting itself. Not surprisingly a large number of photographers were nervous about getting involved in something they knew so little about. So while digital filmmakers made hay, experimenting with new cameras to create scripted films and documentaries on budgets they could not previously have dreamed of, and to capture shots in major motion pictures that were previously unobtainable, photographers hid their heads in the sand. A few did see the creative possibilities and strode forth into a new world of narrative: most notably photographers such as Vincent Laforet, Tim Hetherington, Danfung Dennis, Dan Chung and the hero to the time-lapse community, Philip Bloom. Alongside these professionals, amateurs primarily from the extreme sports and skateboarding community, saw that this inexpensive form of movie making allowed them to capture their death defying stunts. The establishment of Vimeo as a platform for serious digital films—in competition with the more general content of YouTube—provided a showplace for a content hungry audience only too willing to share what they considered to be good, and to pass judgment, both informed and not quite so considered. The community was being formed online and there

**Vimeo is an online platform that has been at the forefront of exhibiting, showing, and marketing short films created by professional filmmakers and photographers, as well as enthusiasts excited by the possibilities that DSLRs offer to create high quality work.**

was no shortage of people willing and able to create the content. But where were the photographers in this burgeoning community? The truth is that apart from a few, they were barely visible.

From my standpoint within the photographic press I was a lone voice. "It's just a gimmick", "It's nothing to do with photography", "It's not for professionals", photographic magazine journalists loudly pronounced. The truth was that they were just as scared as many of the photographers. They were afraid that they were about to be usurped by a new form of image capture that they did not understand. They were afraid that if they admitted this they would no longer be of relevance on their respective titles. Many photographers took the same standpoint, and many are still clinging to this way of thinking, just as many did with the change from analog to digital. It was, and it remains, the case that it is the clients requiring engaging web content to entertain, inform, and improve their search engine optimization (SEO) standings who are finally forcing photographers to take the advent of the DSLR moving image seriously. (SEO is the process of improving the visibility of a website or web page within a search engine's natural or unpaid search results. A process that Google favors is the use of video within a site to help improve search ranking and therefore visibility.)

I have never said that photographers have to shoot moving images—I recognize that it does not suit everybody creatively—however, I do believe that photographers have to consider and experiment with it. After all, why wouldn't they if it can be used as a tool to extend creatively and expand the opportunities to tell stories, and create narratives both for themselves and for clients? More importantly perhaps, from a commercial and profes-sional photographic perspective, the moving image is becoming a client's expectation of the photographer. The use of the word "expectation" is an important one, because pho-tographers will lose commissions if they do not have it in their kit bag, and will continue to do so. The Internet is here to stay and so is its demand for engaging content. These factors combined with the fact that every DSLR or compact system camera launched over the last five years has HD video functionality, and every smart phone now has the same, has ensured that every client now sees the creation of moving image as nothing more than a matter of pressing a different button. Whether or not this is true is not the point; the fact is that this is the perception, to which we have to respond.

This availability of the moving image on easily available devices may require adaption from those not born as digital natives, but to those born since the digital revolution the concept of creating a moving image is an obvious extension of the still image. Many see no reason to create a still when they can create the moving interpretation of the same scene, and they are the future of our industry. To those more dyed in the wool within their photographic practice and who are struggling with the concept of the moving image, I'd like to offer this thought.

If we think back to the days of the analog contact sheet, and see the contact sheet for what it was, it was a series of images in sequence that tell the story of what the photographer witnessed and chose to capture. The contact sheet is a storyboard for a film that was never made. That sequence of stills could also be considered as frames from a movie without sound. With this understanding, the progression from the still to the moving image seems a very small one and completely logical for the photographer to progress to. Let's also not forget the long history of photographers making films. From the end of the nineteenth century, to the films of Paul Strand, Bert Stern's classic *Jazz On a Summer's Day*, Gordon Park's seminal *Shaft*, and on to the present day with Anton Corbijn's art house successes *Control* and *The American*, photographers have been fascinated by and involved with the process of filmmaking; now they can do it independently without outside finance and influence.

We are in the earliest days of this moving image revolution and at present clients' expectations are, on the whole, not particularly demanding. They are often happy to receive the moving image content photographers want to give them, within the budget they have set (do not expect to get extra budget for the moving element of a shoot, it may happen and arguably it should happen but increasingly I hear that it is not happening; similarly, do not enter this field purely as an extra revenue stream, despite what others may say you will be extremely disappointed with your return). However, this is changing and will definitely change over the coming years, as clients become more demanding in the quality and scope of the moving image they expect. To respond to this and also to help photographers get started in this field that is new for many, I have compiled a checklist of considerations that need to be taken into account.

## How to Respond to The Moving Image
▼

1. Be prepared to invest in the right equipment at a quality appropriate for the rigors of filmmaking. This will include tripods, fluid heads, sound recording equipment, microphones, editing software, memory cards, and possibly rigs and other specific kit appropriate for the films you want to make.

2. Bad sound is bad sound. You will need to get your audio right the first time—it can rarely be saved or improved in post-production.

3. Speaking of sound, look to build "soundscapes" rather than relying on one piece of music as the soundtrack.

4. Look to create narrative within your work and avoid the temptation to create a beautiful looking film composed of a series of well-constructed images with little depth of purpose.

5. Be prepared to work within a team. Still photography is primarily a solitary practice with the photographer controlling the whole process. Filmmaking is about teamwork and working with others both practically and creatively.

6. Avoid clichés and look to original ways to tell your stories, and avoid stories that are clichés. You can research on Vimeo to help you avoid this.

7. If you are going to shoot time-lapse, make sure that you have the right subject for the process.

8. The graphics you use within the film and as title sequences and end credits are important. If you are an inexperienced designer or typographer, work with someone who can set the right identity for your film.

9. Don't forget to shoot stills of the making of your film and to capture key moments or characters to use as marketing and promotion stills of the film when it is finished.

10. Create a showreel (an edited selection of your film work on DVD and online; think of this as a promotional trailer for your work), and include films on your website. Although I know of photographers who have been commissioned to shoot moving image purely on the strength of their stills, I also know of those who have lost commissions as they did not have a showreel to show. The showreel does not have to consist of commissioned films as good personal work always shows personality and passion—two key elements in getting commissioned.

Now that the dust has settled on the explosion of moving image functionality within DSLR cameras and the majority of professional photographers have accepted that the arrival of that functionality has not meant the death of the still image, it is becoming increasingly obvious that the moving image is an essential commercial and creative tool within a photographer's kit bag. It is also clear that the genre of moving image has different parameters in both construction and delivery from that of traditional filmmaking, while also sharing a number of its intrinsic qualities. Photographers are beginning to make their presence felt by creating documentaries, short films, and experimental pieces, that are based on their unique experience of composition, lighting, and post-production aesthetics, while also using that experimentation to inform their still image creation. As with all dramatic change that is disruptive and challenging, the arrival of the moving image into the photographic world was not initially universally accepted. However, that acceptance is fast becoming a widespread reality.

## WHO ARE THE NEW COMMISSIONERS?

It is not only the environment of commissioning that has drastically changed over the last decade. The profiles and titles of the people who commission have also changed. Where once the art director, art buyer, and photo/picture editor were all powerful and the sole contacts for photographers to show their work, they have now been replaced by myriad titles and levels of experience of the very subject on which decisions are being made. My personal approach to commissioning was purely based on that of the great art director of *Harper's Bazaar* magazine from 1938 to 1958, Alexey Brodovitch (Brodovitch mentored iconic photographers such as Richard Avedon, Eve Arnold, Art Kane, and Hiro among many others), who would use just two words to commission: "Surprise me!" Today you simply cannot expect the person who is commissioning the photographer to have any interest in, or experience of, photography or the confidence in the photographer's talent that Brodovitch displayed. I say "expect" because, of course, there are still some excellent, passionate, and informed commissioners out there looking to build mutually beneficial relationships with photographers. However, there are far more who possess none of these qualities. Today photography could be commissioned by a picture editor, photo editor, art editor, researcher, homes editor, senior designer, designer, creative director, art director, junior assistant, PR executive, marketing assistant, and on and on. Those are just some of the titles I have been personally commissioned by, and as the titles suggest,

the experience of the person is not the only variable. So is their knowledge of the process of commissioning. On many occasions I have found myself in the position of having to gently explain to the person commissioning, how to commission. The information I need, the pitfalls to consider, and the reality of what they need, in what format, and how they will be using the finished images. The reason for these inexperienced commissioners throughout the industry and the commercial landscape is primarily economic. The art of commissioning—and at its best it is an art—is no longer seen by accounts departments as a justifiable sole skill; instead it is rolled into countless other elements of any other role. Just as anybody today can be a photographer, similarly anybody can commission photography. It's easy, right? All you do is phone the photographer up and ask them to do something. Of course, the professional photographer knows the reality of this statement, and the possible outcomes of working with a client judging them from a position of ignorance. This ignorance can result in either an over-controlling client expecting to receive the impossible or a "hands-off" client who expects the photographer to make all of the decisions only to be disappointed that the photographer has not done what they wanted—despite the fact that they never told the photographer what they wanted.

Now this is a difficult position to find oneself in. The balance between controlling the negotiation and commission, while not becoming overbearing or dismissive of the client's knowledge, is a difficult one to get right. It is essential that the photographer shows empathy for the commissioner's position no matter how experienced they are. It is also vital that the photographer brings their hard earned experience to the situation to protect themselves from an ill-conceived commission that could easily backfire and damage their reputation. In this respect it is worth practicing this situation with a friend who can play the role of the hapless commissioner, to ensure that some stock phrases are to hand to deal with a number of common situations that may occur. To help with this I have compiled a short checklist based on my personal experience.

## Dealing with The Inexperienced Commissioner
▼

1. Never ask what the fee is (the commissioner probably has not considered this and may be shocked at what your expectation is in relation to their own salary). Always ask what the budget is and then see if you can work within the budget.
2. They will probably have little understanding of JPEGs, TIFFS, and RAW files. Ensure that you have a simple metaphor to explain this to ensure understanding of

the content delivery process. I always use the example of a vinyl record, a CD, and a downloadable MPEG file to explain the concept of compression of information and therefore quality.

3. If you intend to work with an assistant explain all of the reasons why this is important. The commissioner will think that they are employing a photographer and will probably have little understanding of why an assistant is so important to you.

4. Clearly state your personal situation concerning usage and ownership of the work. Many inexperienced commissioners will assume that once they have paid you they will own all of the work, without even having to ask you to sign over your usage rights.

5. Ensure that you create a paper trail of e-mails between you and the commissioner noting all of the decisions made leading up to a shoot as proof of both parties' involvement in the decision making process and the agreements made. This can be an essential protection if the commission goes wrong. To ensure that this is complete always follow up on phone conversations with an e-mail outlining what was said.

An experienced professional photographer who understands the commissioning process should be able to deal with an inexperienced commissioner, but it is still easy to forget some of the basic tips I have outlined in the checklist. However, the young photographer who is inexperienced in the process will find it more difficult. Unfortunately, there is no magic formula that I can give that applies to every situation. To a great extent dealing with clients is a learning process that everyone has to go through and sometimes it will go wrong. What is important is that lessons are learnt from the bad situations and that they are not repeated. Although as I have said there is no magic formula, below are a few important questions, in no particular order, that both young and established photographers need to ensure they ask to prevent future problems occurring. Again they may appear to be obvious but it amazes me how often I have not been asked these questions, despite the fact that by asking them the photographer would have a clear and detailed idea upon which to decide whether or not to accept the commission.

## The Essential Commission Questions to Ask

▼

1. How are the images going to be used? Will they be used in print and online?
2. Do you intend to own the rights for the images?
3. Is there a shooting brief and schedule?
4. Will you be organizing the shoot? Location, models, hair and make-up, styling, etc.
5. Will there be any embargo on the images?
6. Will I be able to use them for personal promotion on my website?
7. Are you able to pay for an assistant and/or equipment hire?
8. Do you require a match print to be submitted with the final digital files?
9. Is there a requirement for post-production work? If so, will you arrange that or should I? Is there a separate budget for this?
10. Will the client/commissioner be attending the shoot?

# GETTING ON-TRACK ONLINE

**THE DIGITAL REVOLUTION OF THE PAST** seven years has changed the way in which we capture images, the equipment we use, how we process and produce our images, how we store our images, how our clients communicate with us, and how our images are used. It has increased creative opportunities but, perhaps most importantly, it has created new ways to show the world our work and our personality. I use the word "personality" deliberately as it is the understanding of the importance of an online personality that is the most misunderstood secret to online success. When I refer to online I am referring to every form of interaction it is possible to have via digital platforms. It is vital to understand these basic concepts to understand how and why it is so important to use all of the appropriate online platforms available to you, to create a successful photographic practice. Whichever platforms you decide to use, the moment you begin to post information you become a publisher—someone who curates information for a defined audience and who distributes that information to that audience. This is a role that the twenty-first century photographer has to both understand and embrace.

## YOUR WEBSITE IS YOUR SHOP WINDOW

I am going to begin the discussion about how to build an online presence successfully by talking about the most important of all the platforms a photographer needs to construct: their website. But before I start divulging how to begin this, I'd like to give some personal online historical context. I first started engaging in conversations concerning websites in 1999. I knew nothing about what was possible, why a website was a good thing to have, or how anybody would find my website even if I had one. I was a photographer website virgin, who did not have enough budget, broadband width, or knowledge—although I did buy my URL. Then, while working in Seattle, I heard the term "web architecture" for the first time and suddenly building websites made sense to me. I was still unable to write the code required to build a site in those days of well-paid web builders, but I did understand the concept: Build a structure with solid foundations that can function quickly and that is easy to navigate. That understanding remains the cornerstone of successful websites today.

The early days of photography website construction saw big name photographers with large amounts of money to spend engage in a battle of "who has the most expensive, most technically advanced, most creative website." The more features they had the better; the more glamorous the better; or at least that is what photographers seemed to

believe. The reality was that these sites were often slow to load, overly complicated to navigate, with small images and unnecessary music. Today they look exactly what they were—overly ambitious concepts based on crude technology—and yes, some are still in use. Many of these early sites relied upon flash plug-ins that clients had not installed on their computers, and as the photographers' sites became more and more sophisticated the client was asking for the exact opposite, a simple, quick to download, HTML-based site. Again this basic requirement of a site remains the same today. Keep it simple, that's what clients want.

As well as the high costs that were incurred to build these early sites one of the major problems with them was the additional expense every time it was necessary to update the site with new images or information. The builders owned the build and the code and they were not happy to share either of them. The photographer was totally dependent on the builder: the builder would decide when they would do the work, and they could charge whatever they wanted. This was obviously a situation that was going to have to change for the web to grow; as more people mastered the dark arts of the web-building package Dreamweaver, the cost of sites dropped and they became increasingly easy to build. However, the era of the one man in a bedroom web designer/builder was short lived as entrepreneurs soon saw the commercial possibilities of creating easy to adapt templates with open source code.

**When beginning to create your own website from a template offering, look for a well-designed and easy to use CMS (Content Management System).**

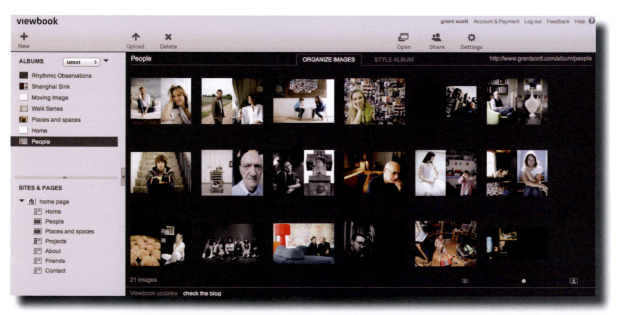

Today the personalized website is available to all, however small your budget and however limited your digital or design expertise. There is no shortage of possibilities for you to choose from. So what should you be looking for when choosing a software platform for your site and how should you construct it?

First let me suggest a metaphor for you to consider. A photographer's website is their shop window, and as with any store it is important that their shop window clearly shows what they sell and that they define their area of specialization. It should also entice potential clients into the store to see more of the products they are selling. A well-laid out shop is easy to enter and allows a client to get to see what they want quickly and easily. The environment of that shop should be appropriate to the products on sale and have clear signage to allow visitors to navigate their way to the departments they are interested in. The departments should integrate well and give a confident expression of the store as a whole. The photographer needs to have a clear understanding of what their website needs to look like before they start to build it. It needs to be a well-defined and successful store.

I'd like to extend that retail metaphor just a little further. Go online now and imagine that you are in a shopping mall and you are looking for a particular item. Obviously you will want to buy from someone who specializes in that item and is going to give you a pleasurable shopping experience. Say you are looking to buy a pair of sneakers, would you choose to buy them from somebody who also sold sausages, lawnmowers, and rubbish sacks? Of course not, unless you wanted to buy them from a large department store offering a wide selection of goods without any area of expertise.

You do not want your website to be a department store, so do not create a photographic equivalent by including every image you have ever shot from confusing and conflicting areas of practice. "Less is more," was the creed of the great French architect Le Corbusier, and "Less but better," said the German product designer Dieter Rams. Both statements are fundamental to a successful website.

Whenever I am asked to review a photographer's website and I see that the photographer has failed to understand the fundamentals of what a website needs to be I am invariably met with the same responses: "I thought it would be a good idea to give a choice"; "I wanted to show that I've taken lots of pictures"; "I'm giving my potential clients lots of reasons to use me"; and perhaps the most ill-informed, "I can do lots of things and want

to show them all." I hope that these comments make as little sense to you as they do to me each time I hear them. What these photographers are doing is exactly the opposite of their proclaimed intentions. They are actually creating a negative retail experience.

# YOUR WEBSITE IS YOUR FOUNDATION

Your website is the foundation of your business and it needs to be kept simple. You need to edit your work tightly—no more than fifteen images in any particular section—with a sense of narrative when considering which images to include and in which order. This may be a painful process, but it is essential that your decisions are not betrayed by financial or emotional attachment—the background to an image is not an adequate reason for inclusion.

It is always the case that you will be judged on your worst image, as in "I really like those but it's a shame about that one," so ensure that all of the included images are strong—you are only as strong as your weakest image. You need to ensure that your home page features your strongest image, as many commissioners will not go further than this when looking at sites—I know this sounds harsh but it is the reality of our business. You need to make sure that your site is quick to upload even on the oldest PC on the slowest broadband width, so test it in exactly these conditions, across all the commonly used web browsers including Safari, Firefox, and Internet Explorer. The final consideration to bear in mind is how many sections you create within your site and how you name them. Keep this simple and clear. Later in this chapter I will write about the different reasons you should include different sectors but at this point you should include only these: Home, Portfolio, About, and Contact. These should be the sector titles that provide the foundation for your site.

Having established what titles you are going to use, edited the material tightly, and decided on the order of presentation, you are ready to build the website. It is at this point that you will need to consider your URL, building system, and website host. The answer to getting the right URL is: keep it simple. You need a URL that is not gimmicky, supposedly funny, overly long, or difficult to spell. Always try to purchase both the .com and your national online moniker such as .ca, .nl, .hk, or .co.uk to ensure that you can control any future possible use of the URL that may cause you embarrassment, even if you are only

A selection of home pages of companies that supply easy to manipulate downloadable website templates to a standard appropriate for a professional. When choosing your template ensure that the company providing it offers all of the functionality you require for your site. You should also be aware of their range of packages and ensure that you have what you require in the package you can afford. In general, it is always best to consider the package you choose as an investment in your future.

aiming to use the dot com. If you wish to promote yourself as a regional photographer, then you should buy both but use the national domain as your main site URL.

You then need to decide on a host for your site. This is a very competitive market and there are many companies offering this service with a multitude of prices and services. My advice, based on personal experience and a number of mistakes, is to choose a company with a package at a competitive price that gives you a number of e-mail POP accounts as part of the package—this will allow you to set up an e-mail such as info@ yourdomain.com—and a helpline for when things go wrong as they have a tendency to do. It also pays to choose a host on the basis of word-of-mouth recommendation.

Once you have decided on the host you will need to decide on how you are going to build your site and who with. At this point you need to have a clear understanding of the purpose of your website. Do you want to promote your work for commissions? Do you want to sell your work or associated products? Do you want to showcase your moving image? Do you want your site to be easily accessible on tablet and smartphone? Or do you want to use it as a platform for ongoing projects? The chances are that you will want to use your site for many, if not all, of these functions, so it is essential that you research the functionality of the options open to you.

Today, a wide range of easy-to-download templates that can be adapted to your needs are available from a variety of companies and a number of blogging platforms such as WordPress. (Although Tumblr is a good blogging site, it is not appropriate for a professional photographer; neither is Flickr.) Any of these companies may be suitable but a good way of checking that you are making the right choice is to see how many photographers whose work you admire are using that company's services. Word of mouth is also a good form of recommendation, but make sure that you ask people who are already working as professional photographers. If you are a student, asking fellow students is not necessarily going to supply you with the best professional advice.

My recommendation to all photographers starting out or working with small budgets is to use these website template-based companies for a number of reasons. First, doing so puts you in control of the build, design, and build schedule. It allows you to get some basic knowledge of Content Management Systems (CMS). You get a set price for your website, preventing any nasty financial shocks at a later stage. You control the images you post and the order in which they appear, without relying on someone else's work

schedule. And, most importantly, you get a sense of awareness of what is involved in creating a successful site and gain confidence so that you can move on to developing a total online presence. You may choose to employ a website designer; but before you do, be aware of the advantages of creating a site for yourself and ensure that you have access to the CMS to make changes to the website at a later date.

This is not a guidebook on how to build a website, but I have tried to contextualize the importance of a good website as part of your overall presentation. This will help you to understand its basic functions and requirements. Below is a short summary of the points I have made.

### The Essential Considerations When Building A Website
▼

1. Clean and simple design.
2. Easy to understand navigation.
3. Strong, compelling home page image.
4. Quick to download.
5. No more than fifteen images in any one section.
6. Easy to remember and type URL.
7. Only use new images when they are better than the images you already have on the site; never update just because the images are your latest work.
8. No background music.
9. Functionality for future growth.
10. Appropriate for your client market.

# TO BLOG OR NOT TO BLOG, THAT IS THE QUESTION

Ok, so if your website is the foundation and shop window of your photographic practice, the blog can provide the added online personality. I say "can" because not everyone can create a personality through a blog; therefore when photographers ask me whether they should have a blog or not I am always careful how I answer the question. The creation and upkeep of a blog requires the skills of a journalist, the patience of a subeditor, and the storytelling capabilities of a seasoned raconteur. Oh! And a lot of hard work! Blogging,

therefore, is not for everyone and yet "the blog" has taken on almost mythical status in its power to help you grow web traffic. Quite simply, not everyone can create a blog and not everyone should try.

So what is the purpose of the blog apart from driving web traffic? Well, it can provide background to your work, it can provide context for your work, and it can showcase who you are, what you like, where you go, what you do, and, most importantly, what and how you see. For all of these reasons, a blog can be a very important element in creating your online personality. These days clients rarely meet new photographers in person; they meet you online via your website. Although you will want to be judged on your work, clients will also want to know what kind of person you are and how you approach photography. You may well win the commission over a fellow photographer on the basis of these aspects.

There are three distinct forms of blogs. The first is what I will refer to as a "general photo" blog. This is the kind of blog that takes the most time to create and that will require the most input of content. It requires awareness of what's going on in the world of photography and features comments, reviews, and statements written about your personal work, as well as your technique and equipment. This type of blog is created to build web traffic and therefore a community. The second type of blog is a "work blog," which records the work you are doing and the images you are taking with photographs and text. This kind of blog provides the context for your work and does not involve a huge amount of journalistic input. However, it does require regular updating and a reasonably robust commissioning schedule to ensure that you appear both busy and successful to clients and potential clients. The third, and perhaps the easiest blog to control and keep fresh, is the "photo diary blog." This blog is image led and consists of the pictures you take that interest you. This type of blog works well on two levels. First it demonstrates how you see and your visual language, and second it encourages you to take images wherever you are and thereby develop your visual language. On this platform, you can display images covering a wider selection of photographic genres without weakening the main area of specialization demonstrated on your website. If you have never created a blog before, this is where I would recommend you start. Once you have created a blog you should then link it to your website with a simple button on the home page titled: Journal.

# THE DAILY CHESSUM

2012-09-24

ASK ME ANYTHING

ARCHIVE / RSS

A sampling of photographer created blogs that demonstrate three different approaches that can be adopted. *The Daily Chessum* is created by New York-based portrait photographer and filmmaker Jake Chessum and is a purely visual blog. *News Shooter* is created by Beijing-based photojournalist and filmmaker Dan Chung and is a news, review, and comment-based blog. While London-based portrait photographer and filmmaker Chris Floyd's blog is based on his commissions and features his written analysis and thoughts on his images, experiences, and photographic practice.

News|Shooter

ABOUT | CONTACT | BLOG

NON 5D RAW HACK – USEFUL FOR REAL WORLD
DDUCTION?

editor Dan Chung:

click here

s from James Miller on Vimeo.

- so I am officially impressed. A week after the Magic Lantern team unveiled their Canon DSLR RAW

CHRIS FLOYD

PORTFOLIOS   INFO

LATEST POSTS

EXPLORE

### The Way I Dress: Mr Andrew Weitz

5 MAY 13

SEARCH

"Everyone's so scared. Don't be scared." In this new short for Mr Porter, Hollywood talent agent, Andrew Weitz, takes pride in the fact that his more conservative colleagues make fun of his style and that this spurs him on to buy more of the things they are baffled by. A lot of people have asked me if this is the house where Cameron wrecked his dad's Ferrari in 'Ferris Bueller's Day Off'. I wish it was, I truly do. Unfortunately, it is not.

SUBSCRIBE VIA EMAIL

Enter your email address to subscribe to this blog and receive notifications of new posts by email.

Email Address

SUBSCRIBE

0 COMMENTS

THE ARCHIVE

### The Way I Dress: Mr Nick Waterhouse

4 APR 13

May 2013
April 2013
January 2013
December 2012
November 2012
October 2012
August 2012

I have described the positive reasons for having a blog and the positive impact a well-constructed blog can have on your career; but there is also a dark and negative side to blogs that you need to avoid at all costs. These are some of the absolute "no-nos" when creating and maintaining a blog, all of which I have seen on photographers' blogs at one time or another.

### The Blogging No-Nos

▼

1.  Beware of making political statements.
2.  Do not say what you had for breakfast or mention the weather, unless either or both are of importance to others.
3.  Do not make jokes. Humor is subjective.
4.  Do not post sexually explicit content.
5.  Do not bad-mouth other photographers or clients.

# TO USE SOCIAL MEDIA YOU NEED TO BE A SOCIAL BEING

Before we start to discuss how to use social media successfully, let's all agree on what social media is. If we strip away all the people who engage with social media and all the activity on it, social media platforms are nothing more than software packages. They are products created from digital code; nothing more and nothing less. What makes them anything more than this is the global population that uses them. We provide the content, we dictate how we use them, and for what purpose.

If you accept this proposition, then you have the basic understanding required to use social media successfully, both socially and professionally; but only if you also understand that these two approaches must co-exist as part of your extended online personality. Imagine that you are at a party and you meet somebody for the first time. They introduce themselves as a used car dealer and you engage in conversation. You mention that you might be looking for a car and they say that they have just the car for you and ask when you can come and see the one they have in mind, and of course they'll negotiate on price. You are at a social event and don't appreciate such a hard sell and move away to speak to another guest. The next person you meet is entertaining and engaging, so

conversation flows. After some time you ask what they do only to discover that they also sell used cars. You mention once again that you might be looking for a car. They say that they would happily help you out if you want them to, anytime you're ready to look at a car just ring. You appreciate the offer and respond positively. They have been professional and social within a social environment. That is how to make social media work for you. Avoid the hard sell and never be overly aggressive or inappropriate. Keep your personal life outside of your professional activity and do not confuse a social situation with a professional one. Photos of you at a drunken party posted on Facebook are not going to enamor you to a potential client, so make sure you keep your private life private.

Facebook is a slow social media platform that retains information on show and allows others to comment at their leisure. In this respect it is an excellent platform to create a community that you can then direct toward your website. On every commercial website I have established, Facebook has been the second most successful driver of traffic after Google. Twitter is the opposite of this: It is a super-fast media platform that is constantly refreshing itself with new information. It therefore takes more effort to convey messages, as you may have to constantly tweet the same message to reach as much of your Twitter community as possible. Even so, Twitter is an extremely effective global message board and an effective driver of traffic to your website. It is also a great way of interacting with fellow photographers and members of the global photographic community, via re-tweeting and following. The mutually supportive nature of Twitter is demonstrated on a weekly basis through Follow Friday, where people suggest other people to follow to their own following via the hashtag #FF.

The UK based photographer and filmmaker, Chris Floyd, is a keen exponent of Twitter. He recognized that the interaction he was having on Twitter with people he had never met had replaced the in-person conversations he had previously had with fellow photographers at the darkroom, where as an analog photographer he would drop off film and pick up prints. This realization led him in 2010 to create the photographic project *One Hundred and Forty Characters*, in which he photographed the people he regularly communicated with on Twitter but had never met. The project took a year to complete and then went on to be published as a book, exhibited in a traveling solo show, and become an excellent catalyst for future commissions. What Chris realized was not only Twitter's place in the twenty-first century photographer's social interaction but also its power to bring together people on both a social and professional level.

**One Hundred and Forty Characters by Chris Floyd** In July 2010 I decided to begin photographing people that I follow on Twitter. The idea for this came at a moment when I realised I had not seen or spoken to any of my best half a dozen real and actual friends for over a month. Some of those people on Twitter I communicate with several times a week, in bursts of 140 characters or less, and yet I had never met any of them. As we are now well and truly living in a digital age I am aware that this state of being is only going to deepen and the traditional forms of friendship, although they will not go away anytime soon, are going to have to make room for the new way of doing things. Where Facebook might be considered as the place in which you tell lies to all the people you went to school with, I had begun to think of Twitter as the place where you tell the truth to all those that you wish you'd gone to school with. The project rolled on indefinitely for almost a year but when, one day, I counted up the number of subjects to date and came to a number in the mid one hundred and thirties, I immediately knew where this had to end. So here they are. My new friends. 140 characters. No more and no less. **www.chrisfloyd.com**

Printed by Gavin Martin Colournet Limited on Xxxxxxxxxxxxxxxxxxxxxxxxxxxxxxxxxxxxxxxxx. www.gavinmartin.co.uk Typeset in ITC Franklin Narrow. Design by Wayne Ford.

The poster created by photographer Chris Floyd to promote the exhibition of his work inspired by his Twitter interactions, *One Hundred and Forty Characters*.

These images are part of a larger body of work titled *One Hundred and Forty Characters*, created by photographer and filmmaker Chris Floyd. Floyd recognized the power of the Twitter community in his professional practice and the death of the social aspect of the traditional darkroom. His response to this realization was to photograph and meet the people he regularly connected with on the social media platform.

# BEYOND FACEBOOK AND TWITTER

Facebook and Twitter are the two main platforms that professional photographers use to build their online communities, promote their work, and develop online personalities. However, there are others that need to be considered and understood.

LinkedIn is a professional business network, which, when used as a basic free networking platform, can be an effective way to research client backgrounds. It also offers a job service that can be useful if you are looking to work for a company on a full-time basis. Unfortunately, although you can join open groups, many people are very protective of their connections, and are unlikely to connect with you if they do not know you. LinkedIn therefore works well if you already have a client base or are actively networking within the industry, but is less useful for photographers who are just starting out.

Another way of building a community and marketing yourself and work online is through podcasting and vodcasting. A podcast is an audio broadcast and a vodcast is a filmed broadcast.

**LinkedIn is primarily used as a business connection. It is an information and community-building platform.**

A series of screen captures created from the appropriate multiple platforms upon which my project, "The United Nations of Photography," exists. These demonstrate the importance for our community of both existing across a number of potential interaction points and of creating a consistent visual identity across all platforms.

Both require you to compile and present interesting content related directly to your work or to other photographers' work toward which you feel empathy. Once created, you can easily post podcasts or vodcasts onto a blog and onto iTunes via your own iTunes page for free. Both of these require only basic recording equipment to get started and are excellent additions to a photographer's network of digital marketing platforms. However, as with the creation of a blog, both of these need to be entertaining and informative. If they are neither, they will not do you any favors and can have a negative effect on your career—so beware of rushing into creating or launching either.

**After its initial phenomenal growth and worldwide adoption by the global photographic community, Flickr has become overloaded with generic images and amateur/enthusiast users.**

Of all of the online platforms, perhaps the two that are most directly related to the photographic world are Flickr and Instagram. Both have had an impact on the professional world of photography, but from very different aspects. It would also be true to say that the former's impact is fading, while the latter's is in the ascendency.

Flickr was never a platform that was universally adopted by the established world of professional photography, but it was one that presented a new audience and community to the enthusiast who wanted to progress their interest in photography, without the investment in a high-priced personal website build. Initially established as a social network photo sharing site before most people understood or even used the term social network, Flickr rapidly became a mutually supportive network of photographers looking for peer review and inspiration. The energy that these communities created in turn established Flickr as an innovative platform that was always developing and an impressive online library of images created by non-professionals, while also becoming a safe space for

professional photographers to post work outside of their recognized areas of specialization. The Flickr buzz soon spread to those looking for images to use within a commercial context and there are many stories of picture editors and stock agencies scouring Flickr pages for appropriate images to use, some honestly and some without the photographer's permission. As a result of these stories, and the fact that Flickr did help enthusiasts become professionals, its importance in the commercial photographic process became well known. However, as is inevitable with an open source platform such as Flickr, the amount of work that was not of a high standard soon swamped the work of quality. The resulting influx of images has made the site difficult to navigate from a professional perspective. As those early Flickr pioneers and early adopters moved into the professional world, the site has become home to a mass of images of indeterminate quality. This, combined with the company becoming part of the Yahoo! Portfolio, has seen Flickr become a shadow of its former self, lacking in both product innovation and funding resources. Flickr was an intrinsic part of the establishment of online photographic communities upon which much of the New Landscape is based. However, I do not believe that it maintains that influence today or will regain its status in the future in the eyes of the professional photographer.

**News organizations and amateurs have adopted the Instagram app on smartphones to document everyday events and the minutiae of twenty-first century life.**

As Flickr continues to lose its initial impetus, Instagram seems to be in the ascendancy, though it is not yet an obvious or globally accepted professional platform and/or process of digital image capture. Instagram's filters and easy-to-download free apps appeal to amateurs happy to use their phone or tablet to create images. It has not been considered by many professional photographers to be either "serious" or "professional." Instagram's official description shows little intent to change that perception by stating that it's "a fast, beautiful and fun way to share your photos with friends and family." However, its status among professional photojournalists changed dramatically thanks to one decision made by *Time* magazine in late October 2012. With Hurricane Sandy fast approaching the Eastern Sea Board, *Time* magazine's director of photography, Kira Pollack, rounded up five photographers and gave them access to the magazine's Instagram feed. He chose Michael Christopher Brown, Benjamin Lowy, Ed Kashi, Andrew Quilty, and Stephen Wilkes, all of whom were established heavy users of Instagram and award-winning photojournalists.

Pollack wanted to ensure that he had the fastest and most direct route to cover whatever events unfolded and get images to his readers. Instagram seemed to be the obvious answer and the fact that the chosen photographers would be covering those events with their smartphones and not professional cameras was not an issue. The resulting portfolio of images was posted on *Time's* photography blog, and was responsible for 13 percent of all the site's traffic during a week when Time.com had its fourth-biggest day since its inception. The magazine's Instagram account attracted 12,000 new followers during a 48-hour period. Pollack's brave and creative decision had been validated and serious photojournalism had been created using camera phones. The very equipment and plat-forms that had been adopted by the citizen journalist had been accepted by the world of professional photography.

Instagram's ability to deliver news images is now recognized by the community, but how Instagram will impact the wider world of professional photographic practice is yet to be seen. Many photographers have embraced Instagram as a photographic sketching tool and process by which to document their daily observations, but as long as the file size is limited as it is at present, it is hard to see Instagram being widely used as a form of professional digital capture.

# DIGITAL ETIQUETTE

The online community is a fickle beast that has created its own rules of engagement, which it regularly breaks and re-writes. However, it would serve you well to follow a basic etiquette. Many of these points may appear as obvious common sense and, to many of you, ridiculously condescending, but I guarantee that you will all know somebody who is guilty of at least one of these online faux pas even if you have not committed one yourself . . . yet!

My first piece of advice may seem to be a strange one but it is an essential sign to look out for. Do not become an online addict who allows social media and digital devices to take over their life. Constantly tweeting and posting will not only affect your personal social life in a negative way, it will give the wrong message to your community. You don't want to come across as someone who has nothing in their life other than Twitter and Facebook. Second, do not fill your professional Instagram account with images of your family and friends. And definitely do not go filter crazy! If you decide to post images you create and want to be perceived as a professional, be aware that a simple Google search of your name will bring up all of the platforms on which you are posting images. If you do not want to be judged by an image out of context, then don't post it.

The first commandment of the Internet is not to be nastier online than you are in real life, and yet it is the easiest rule to forget. Avoid sarcastic comments, righteous opinions, and any comment that could be perceived as bullying or racist. Don't forget that an ill-chosen comment will remain available online for others to see and read for years; sometimes even if you delete them. While I'm on the subject of the ill-conceived comment, it is worth bearing in mind that if you are going to post work or opinions online, you are opening yourself up to both positive and negative comment. The Internet is not for the faint hearted, so learn to accept both constructive and destructive criticism with a level headed approach and take neither as a personal attack, even if it is one.

Be professional. I recently received an e-mail from a student requesting a meeting to discuss their portfolio. I knew this student purely on a professional basis and yet she began her e-mail "Hiya" and ended it with a smiley face. When I mentioned the inappropriateness of her e-mail she was shocked. She considered her approach both friendly and appropriate and my advice old fashioned and overly formal. I leave it to you to make up your own mind as to which of us was correct but here is my rule on how to address an

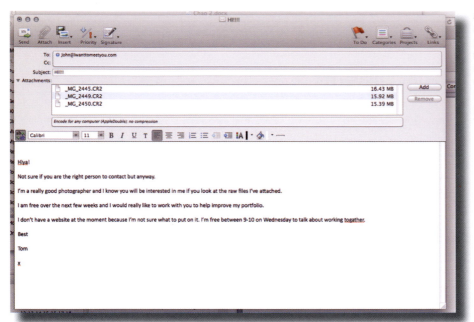

A composite e-mail featuring all of the mistakes that photographers can make when contacting a potential client. This is based on actual e-mails I have received from both young and experienced professional photographers.

e-mail: the lower your standing within the industry the more formal you must remain. The niceties of "Dear x" and "Yours Sincerely" may seem archaic, but they are not. They show respect and that is what you need to show to any potential or existing client. Please also never use language that could be misconstrued as being overly familiar!

While we are discussing e-mail etiquette—a potential black hole for a career, if handled badly—you need to bear in mind a number of considerations when communicating with clients you know and those you don't, but whom you want to know about you and your work. A badly constructed e-mail that fails to consider the tips I have outlined in the checklist below will not be read and may never reach its intended destination. So, to prevent your e-mails having the opposite effect to the one you intend, follow these golden rules of e-mail construction and sending. Remember that whether you are sending a single or a group e-mail the same rules apply.

## The Art of Sending An E-Mail

▼

1.  Choose a subject heading that is succinct and accurate for the content and change the subject title if the content changes within a thread. This allows both the client and you to track back and find an e-mail you are looking for quickly and easily.

2.  Never use the subject line "Hi."

3.  Always address the e-mail to the person you are sending it to, especially if you are e-mailing someone for the first time. Always use "Dear *X*," never "Hi."

4.  If you are sending a group e-mail, to announce an exhibition or book launch, for example, always use Bcc and ensure that the receiver cannot see who else you have invited.

5.  If you include a link to your website ensure that it is a "hot link." No client wants to be bothered to cut and paste your URL.

6.  When sending large image files use a sending package platform such as WeTransfer. Never send consecutive e-mails with each containing one large file. If you are attaching files to an e-mail, always check that you have actually attached the files before you press send.

7.  Many companies set a limit on capacity of their staff's e-mail inboxes so do not block these up with large HTML e-mails or attachments.

8.  Be aware of company firewalls. Many companies have firewalls to prevent spam and viruses breaching their security systems. These can block HTML e-mails, attachments, and e-mails containing certain key words. Following up an e-mail with a phone call is a good way of detecting if your e-mail was blocked and if it needs to be re-sent in a different format.

9.  Check your spelling and grammar. Then check it again before clicking send.

10. If you are sending an e-mail promoting your work to people you do not know, send it on Monday to Friday between eleven a.m. and twelve p.m. but never on a Friday afternoon or Monday morning (these are the times when clients will be hoping to go home for the weekend or deleting all of the junk e-mails they have received over the weekend). Also avoid sending e-mails during lunch times, early morning, or late in the afternoon. These are usually times when people are not at their desks and therefore times when inboxes fill up. In the rush to empty full inboxes e-mails from unknown senders are often deleted almost instantly.

11. Do not become an e-mail-sending stalker. Balance how many e-mails you send and how often. If you don't get a response, make a phone call. If the recipient doesn't want to speak with you, accept that it's time to accept defeat.

# IN IT TO WIN IT: COMPETITIONS AND FESTIVALS

One of the results of the communicative power of the new global social media platforms is the proliferation of photographic and filmmaking competitions and festivals. The ease with which these can now be established and promoted online has resulted in a vast array of different types of both being launched, with the inevitable result of a large number to be avoided and a similarly large number to be considered for entry. So how do you work out which to avoid and which to pursue? And why should you even take notice of them?

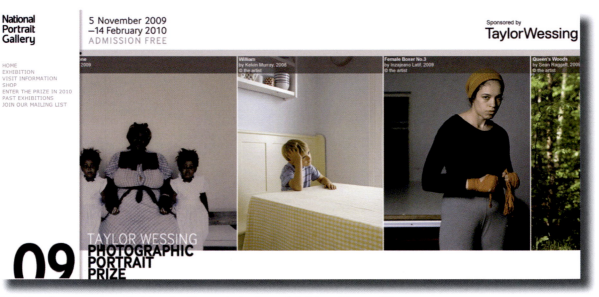

A selection of home pages promoting internationally recognized and respected photographic competitions across a wide range of genres of practice.

I'll answer the last question first. International photographic competition and film festivals have become the main shop windows for photographers and filmmakers, whatever genre of work they are engaged with. The huge range of creative opportunities that DSLR cameras now offer photographers and filmmakers experimenting with the moving image has rejuvenated the film festival format and given rise to a massive growth in the documentary category of work in particular. This rejuvenation has been based on low budget, high quality digital capture and projection, and the establishment of online platforms such as Vimeo to nurture both the creator and the final product. Filmmakers now not only have places in which to present their work, they are also able to promote, market, and distribute their films and videos with the support and help of a community of festivals worldwide. This democratization of the filmmaking and sharing process is the essence of a new interest and generation of creatives telling stories through the medium of the moving image. To these people the film festival provides an opportunity to meet, share, and acclaim work of quality, importance, and interest.

From a photographic perspective the photographic competition and festival has provided not only a sense of community but also an opportunity for work to be seen by acclaimed judges from within the photographic community and commercial commissioners as part of the competition process. The ease with which digital images can be transferred has ensured that entering these competitions is both quick and easy, no matter where you live. The images submitted are often judged by panels of judges who are international in both location and visual perspective and experience. The global photographic community can become very small in this respect, despite national frontiers. The submission numbers to many of these competitions can be vast—one in particular in 2013 received over 120,000 entries—and the impact that competition success within them can have on a photographer's career should not be underestimated. However, simultaneously with the flourishing of the respected photographic competition has come a backlash from the photographers themselves against competitions, which appear to photographers to be nothing more than moneymaking, copyright stealing machines for those organizing them. This backlash has made both photographers and competition organizers nervous and cautious about the payment-for-entry stipulation so many require in order to survive. You will have to make your own decisions as to which competitions you enter, but you need to consider those appropriate to your work as part of your marketing plan. My suggestion would be to check the small print before entering any competition and avoid: those that claim that by entering you hand over the copyright to your images; those that have an entry fee which you feel is too high in

respect to the nature and potential worth of the competition; and any competition which cannot demonstrate its professional credentials.

## YOUR PERSONAL DIGITAL NETWORK

I hope that you now understand why it is so important to use the various online platforms available to you to ensure that you are fully engaged as a twenty-first century photographer. I am not saying that you need to use all of them, but it is vital that you consider and fully understand them, whether you dismiss them or adopt them as part of your photographic practice. The most important consideration is that whatever platforms you do decide to adopt, you must ensure that they are all appropriate for your existing and potential client base and that they form a cohesive network that projects a cohesive message. Your online personality, aka brand, is the personality by which the largest number of people will know you—and judge you. The person you strive to be in real life must be the person you project online.

# THE POWER OF THE PERSONAL PROJECT

**WE ALL COME TO PHOTOGRAPHY THROUGH** a desire to create images of the things that we see, from a personal perspective. As Picasso observed, "Every child is an artist. The problem is how to remain an artist once we grow up." Unfortunately, individual life experiences make us lose our intuitive ability to create images without thought. However, our personal visual language is determined by our ability to create our images from the heart, allowing them not to be controlled by the head but only to be informed by it. Through the creation of personal work we can explore the concept of developing our personal language, while telling the stories that most interest us, using our life experiences to inform our creativity. Personal work is an essential factor in the DNA of the twenty-first century photographer.

Why? Well it's important to understand that in an environment in which the ability to capture quality images is available to all, the only difference between one photographer and another is the individual life experiences that shape the photographer's unique personality and the way in which they see the world. This difference dictates our individual personal language and therefore the originality of the images we create. A unique personal language can rarely be created within photography by the adoption of a lighting technique or post-production effect available to anyone who decides to master those surface skills. It has to be developed through hard work, understanding, and original thought. This is why the creation of personal work cannot be ignored by photographers and is demanded by their clients, looking for a reason to commission.

As I have stated, we all start out as photographers taking images purely for the experience of capturing moments; we do not expect to be paid. But as we start to see photography as a career path, so the expectation of financial recompense for our labors becomes greater, until it can become our sole motivation for lifting our cameras to our eyes. At this point, personal creativity can reach a photographic dead end, especially when the phone has stopped ringing and the clients have dried up. Personal work keeps you connected with why you first fell in love with photography and allows you to develop your visual personal language. It is therefore essential and cannot be ignored as part of your professional photographic practice.

Once you have understood the reason why you need to create personal work, the next stage is to decide on the work you want to create and the format it is going to take within your existing body of work. This is the point at which you start providing some form of structure—however loose that structure may be at the start of the project—to the images you are creating, and the stories you want to tell.

# PHOTO SKETCHING

Whenever I speak with photographers and students whose work appears to have become too stiff, soulless, or overly concerned with technique, I always encourage them to begin "sketching" with their camera (rapidly capturing images without extensive consideration of the images that are being captured). For ease of use and availability, this is usually best done with a smart phone, compact system camera, or pocket camera. Photo sketching breaks down the psychological barrier that many people create for themselves based on the ability to take a "good" photograph. It reduces the fear of failure that hampers so many young and seasoned photographers and encourages experimentation in composition and technique. The golden rule of professional photography is to learn the rules

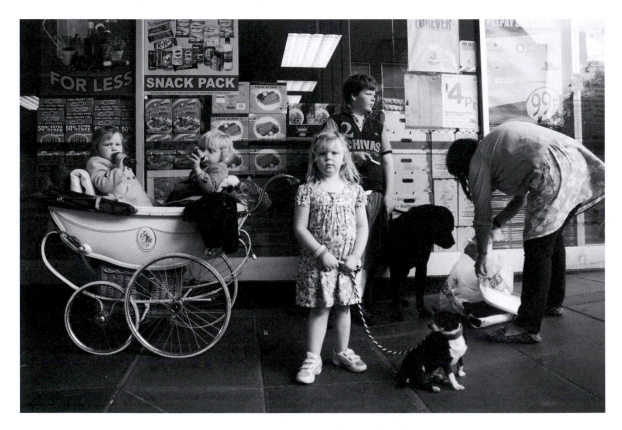

A selection of images created by photographer Jim Mortram from his body of work titled *Small Town Inertia*.

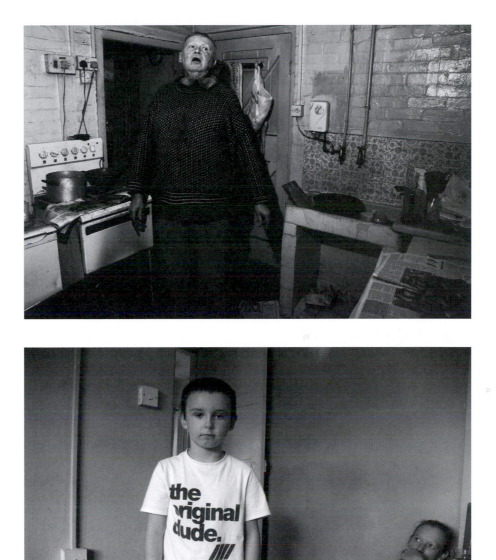

and then know when to break them, never to live by them. Photo sketching promotes this attitude and therefore helps your work to grow. What it also does is lead you into creating personal images; but this is personal work without structure, a group of images without a linking narrative. As I have previously outlined, the narrative will define the work as that of a photographer.

The personal project is not only an essential form of personal creative growth, it has also become the most important element of a professional photographer's client-facing persona for that very reason. The personal project can be whatever you want it to be. It can take whatever form you want it to take. You can work on as many projects at one time as you choose. It can be showcased however you want it to be shown, and it can take as long or as short a period of time that you want it to take to complete. The options are endless but whatever you decide to create, it has to be personal to you by definition; it has to be something that is important to you creatively and intellectually. The personal project is an undertaking that you will have to work on for free and that will take a lot of your time, effort, and possibly investment, so you need to ensure before you begin that you are fully committed to the project you are considering.

The personal project is one not to be avoided, dismissed, or ignored. Since the dawn of the digital revolution it has become the lifeblood pumping around the body of the global network of photographic commissions, competitions, exhibitions, and festivals. Personal work is what commissioners want to see, and it is the work that I see most often; it is therefore almost impossible to choose one image to demonstrate the power that a well-constructed and developed project can have for the photographer who creates it. However, a photographer based in the United Kingdom created a project that has received international acclaim and is worthy of discussion.

# THE EMOTIONAL PROJECT

Jim Mortram lives in Norfolk, a semi-rural area in the east of England ill-served by motorways or public services. There is little local industry and the regional economy is dependent on agriculture, small-scale retail, and government handouts. This environment is the basis of Jim's personal project *Small Town Inertia*. Created within a three mile radius of his home *Small Town Inertia* documents the downtrodden, the underprivileged, the disabled, the traumatized, and the forgotten that populate the small town where Jim lives. His images are dark, bleak, honest, and, most importantly, respectful of his subjects. Neither his images nor his photographic approach are obviously commercial. However, his work is being noticed globally.

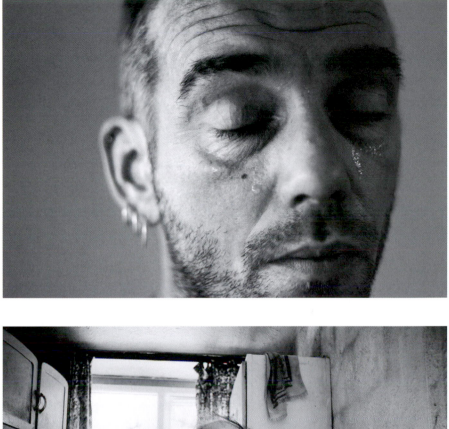

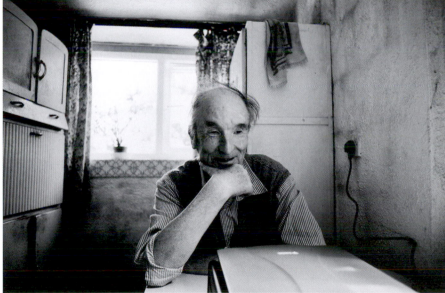

These images from Jim Mortram's *Small Town Inertia* body of work demonstrate both his empathy and respect for the people he chooses to document. Mortram refuses to describe the people in his images as "subjects" as he is intrinsically involved in all aspects of their lives within his photographic documentation.

Jim has created a website for his work that he promotes via a sophisticated and dedicated use of social media, particularly Twitter. This online exposure of his work has led to exhibitions, print sales, offers of commissions, and a limited edition book of the work, which sold out within twelve hours of being announced on Twitter, even before it had even been printed. In addition to creating still images, he is also developing his moving image skills, as well as using his work and online community to raise funds for charities connected with his subject matter. For Jim Mortram, the personal project has been a form of personal expression, a means to gain international exposure, and a launch pad for himself as a photographer.

Jim's work is extremely personal to him and is a reflection of both his life experiences and issues that he feels need to be explored and shown to as wide an audience as possible. His choice of personal project was not only obvious to him, it was a decision fundamental to his life. But how do you choose a project to work on if you are not as passionately engaged with a subject as he is? My advice would be to divide possible areas of investigation into two distinct areas, "emotional" and "intellectual." The emotional genre of personal projects includes all of those stories that are close to your personal life experience. They are often small in scale but rich in detail and can offer a chance to explore a subject in depth with both sensitivity and understanding. Projects that are approached on this basis are often long term projects, which grow and develop over a matter of months or years at a pace appropriate to the subject matter being photographed.

The New York-based, UK-born photographer, Steve Pyke, has been working on a number of emotional projects throughout his career. One particular project titled *Jack and Duncan* documents his two sons from the moment each was just twenty minutes old. He photographed both Jack and Duncan every few months in exactly the same way, showing the way in which their faces evolved over the twenty-five years he worked on the project, before exhibiting the work on Jack's twenty-fifth birthday. This is just one of the many personal projects, both emotional and intellectual, that Pyke has worked on while also working as a photographer for a variety of international clients, and as a contract photographer for *The New Yorker* magazine. Pyke has always seen the benefit of the personal project to his photographic practice. A series of books or an exhibition results from each project when he feels that it is complete or has reached a stage when it is ready to be seen as a work in progress.

Mortram's second book of work, published by the independent publisher Café Royal Books, titled *Living With Epilepsy*, deals with the subject with both sensitivity and powerful images.

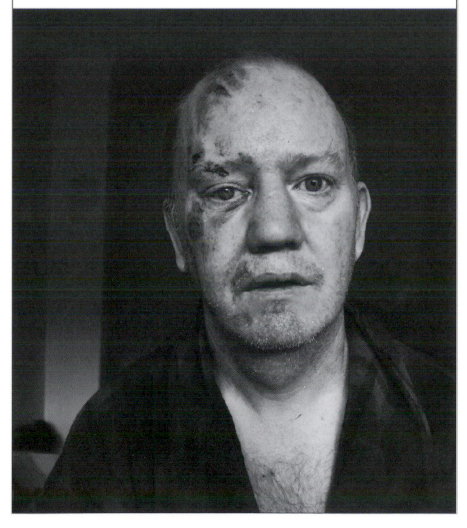

Published by Café Royal
www.caferoyalbooks.com
© 2013 J A Mortram
& Café Royal Books
All rights reserved

Edition of 150

**CRB**

# Living with Epilepsy

J A Mortram

Emotional attachment can be the catalyst for a project but very often that initial emotion intensifies as the project develops and grows. The perfect example of how a project can become something much more emotionally powerful and influential than its initial concept is a three project body of work, created by the Scottish-based photographer Alicia Bruce, titled *Menie: Trumped, Before Trump International Golf Links and A Portrait of A North East Community in Conflict.*

Bruce started working on the project in 2010 out of curiosity and with the promise of an exhibition from a local gallery. The American property developer and television star Donald Trump was proposing to build the "world's greatest golf course" on an area of Scottish coastland that was designated to be of outstanding national beauty and the locals were not happy. Bruce visited the site and was immediately taken aback by the sense of community spirit and the warm welcome she received, which were so different from the media depictions of the area. She made time to meet all of the residents individually, and their hospitality, generous spirit, and enthusiasm for her project were established. She couldn't believe that the residents' story wasn't being told and immediately felt a responsibility to use her images and the resulting exhibition as a way of telling the story from the residents' viewpoint and to show what was about to be lost.

The exhibition opened in January 2011. Portraits made in collaboration with the residents accompanied their personal statements alongside nineteen landscape photographs depicting the wilderness landscape before it was "Trumped." When the exhibition opened it was the first time that the residents had received positive press locally, nationally, and internationally. Bruce found herself acting not only as a photographic spokesperson for the community, but also involved in a battle for land, which stretched from the streets of New York to the head of the Scottish Parliament. As a result she was frequently followed by security and stopped by the police in Menie. However, she knew her rights and never deleted an image or showed the police any of the photographs she was taking.

The political nature and emotional power of the work Bruce created meant that the Scottish Government were the target audience for the multimedia exhibition she created during Scottish Environment Week in 2013. The project had become deeply personal to her and she wanted the decision makers to come face to face with the community she had become so emotionally attached to. The success of her endeavors to bring the stories of that community to the decision makers at government level resulted in Bruce

Photographer Alicia Bruce began documenting the community of Menie, a small town in the north east of Scotland with the intention of creating a body of work to exhibit. Little did she know how involved she would become in their battles against property developer Donald Trump and his construction of an international standard golf course.

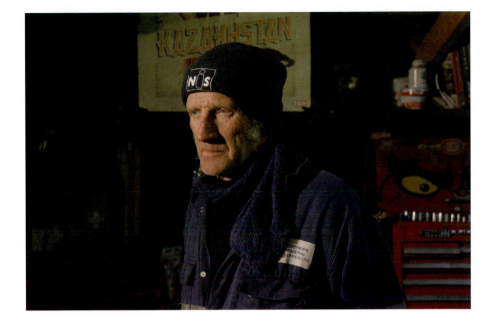

demanding a public inquiry into the handling of the Trump Development. A sense of inquiry and the need to find a project to build into a photographic exhibition had led Bruce into unexpected political waters and emotional engagement with a community desperate for her determined, honest storytelling ability and creative skills to bring their plight to an international audience.

**A selection of images created by photographer Peter Dench from his personal projects *drinkUK* and *loveUK*.**

Another photographer who has been able to bring his personal life experience into both his commercial and personal work is the UK-based, award-winning, social documentary photographer, Peter Dench. Born in a brash, brightly-colored, seaside holiday destination on the south coast of England, Dench brings his hometown's unabashed celebration of vibrant color to his work along with his very personal ironic sense of humor. He has a particular relationship with alcohol that is based in both his family and environmental upbringing. He shares this relationship with a large section of the British population. He explored this relationship in his project *drinkUK* and it also informed the companion project *England Uncensored*. Dench's relationship with these projects is less obviously emotional and direct than Bruce's, but this work is an extension of both his working practice and his life. As such the work is not only authentic and informed but it provides him with a unique visual language that he has been able to extend to the moving image, with resulting commercial success, exhibitions, and a crowd funded book titled *England Uncensored*. Peter's life, beliefs, and influences are laid bare in all that he creates and his clients buy into the personality he displays.

The examples of emotionally-based projects I have outlined so far are all firmly based within an immediate or national environment specific to the photographer creating them. But an emotional foundation for a project can lead to an international-based body of work as well as one of a local nature. Marcus Bleasdale is a British-born photojournalist now based in Norway, but his geographic area of photographic documentation is the Democratic Republic of the Congo. For over twelve years he has documented the conflicts within this war torn nation, addressing the issues that the internal conflicts, fueled by natural resource exploitation, have had on both the country and its population. The work has resulted in the publication of two books, *One Hundred Years of Darkness*[1] and *The Rape of a Nation*[2]. It has been shown to the US Senate, the US House of Representatives, the United Nations, and the House of Parliament in the UK. His images are powerful statements, often dark with menace, filled with tension, and unsettling with their intensity. They are emotionally charged and his sense of justice imbues all of his work as he strives to highlight health and human rights issues, uncovering stories that are underreported by mainstream media. Bleasdale's work is born of his beliefs and commitment in the same way as Jim Mortram's is. However, though he deals with similar issues to Mortram, he does so on a global scale.

The emotional project is often multilayered and although it may begin on a micro-personal level it can both grow and embrace a multitude of elements, people, and environments.

However, its concurrent spine is the desire to create a body of work based on a deep-seated belief or personal experience. This emotional connection to the chosen subject matter helps give the work its visual power and impact.

# THE INTELLECTUAL PROJECT

Intellectually-based photographic projects include all of those that come from a desire for enquiry—the wish to explore a subject about which you may have little knowledge but are intrigued by. That desire to explore and document a subject has been intrinsic to the nature of photography from its earliest days. Initially intellectually-based projects may appear to be the simplest projects to embark upon, as they require little emotional attachment at their beginning and can promise exciting photographic possibilities. However, when our personal interests are so diverse, our subject options become endless and it can become difficult to choose the right subject for you and your photographic language—to define an approach to your chosen subject that will be both photographically challenging and intellectually stimulating. I always advise photographers not to be overly ambitious when looking at an intellectually-based project, to decide upon a potential budget and timeline to create the project, and have a clear idea of their expectation of the body of work before they begin. The same rules apply to all personal projects, but the intellectual project may at times involve extensive travel, exhaustive research, and focused determination to fulfill your initial expectation and the project's full potential. Your ambition must also be tempered by the reality of both your personal and economic situation. There is nothing more disappointing than beginning an ambitious but unrealistic project only to find that it never comes to fruition due to the lack of time or funds to complete it. Personal work takes drive and self-motivation, both of which are quickly diminished by a lack of progress. So choose a line of enquiry that you can achieve, with a realistic expectation of its outcome.

An example of this form of intellectual project that illustrates how such a project can have an important effect on a photographer's career is Magnum photographer Mark Power's *The Shipping Forecast*. Power created this body of work in 1996, and it documents the thirty-one sea areas covered by the nightly BBC radio forecast that includes, among others, Finisterre off the north Portuguese and western Spanish coast, Biscay off the north Spanish and western French coast, the Irish Sea, and south east Iceland. The

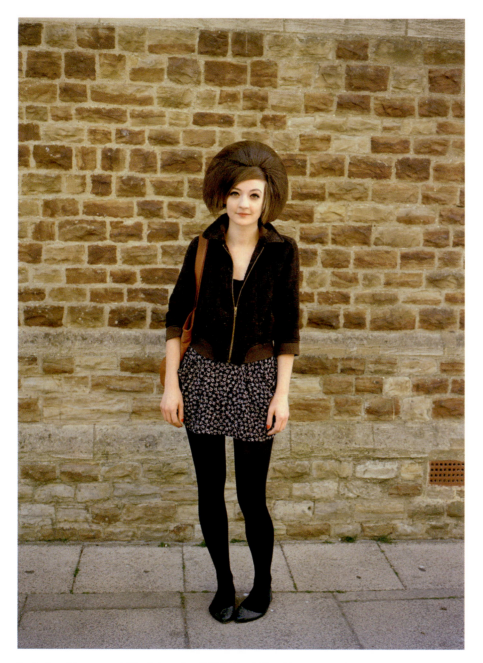

A selection of images created by photographer Niall McDiarmid from his personal project *Crossing Paths*.

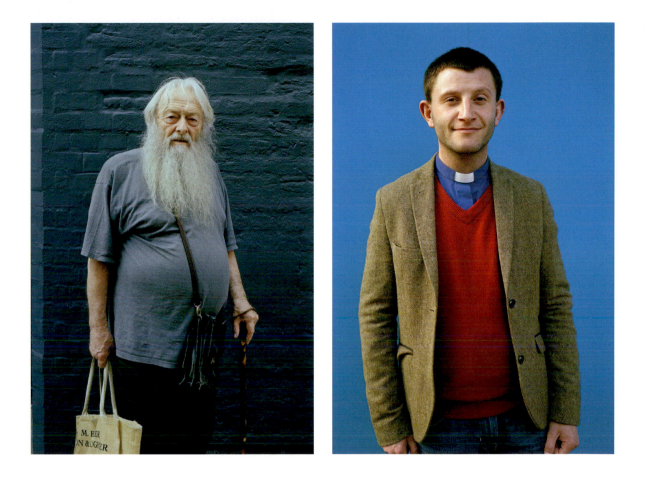

images are soulful, mysterious documentations born of a simple wish to see the geographic locations mentioned in a simple nightly broadcast. The broadcasts were familiar to Power, the locations not so, hence his desire to travel to them and document what he found there. Before becoming a book, the finished work was exhibited in the university in which Power taught. Studied and discussed by theorists and students internationally, *The Shipping Forecast* became an iconic series of images that laid a creative marker for similar projects to follow. It was also what largely led to Power being accepted as a full member by the Magnum agency in 2000.

# DANIEL MEADOWS: EDITED PHOTOGRAPHS FROM THE 70S AND 80S

**VAL WILLIAMS**

The documentary portraits created by photographer Daniel Meadows across Britain in the 1970s were an inspiration to Niall McDiarmid and his *Crossing Paths* project.

As with emotional projects, choosing just one or two intellectual projects to cite as examples of both good and successful creative practice is difficult. However, as with Power's *The Shipping Forecast*, there are some which stand out and are worth commenting on. One of these is Niall McDiarmid's *Crossing Paths*. McDiarmid is a London-based editorial photographer who enjoyed walking around his neighborhood of south London taking pictures of the interesting characters with whom he crossed paths. Pleased with the initial images he was creating, he decided to expand the series to cover the whole of London, visiting areas with which he was previously unfamiliar.

Within a couple of months the project had spread beyond the confines of London as he started to document the characters he met in towns across the south east of England. This, in turn, led to his decision to document the characters he would meet if he traveled to all of the major towns within the UK. He visited over seventy-five towns and photographed over five hundred people before bringing the project to a temporary close and creating a self-published book from an edited selection of the work.

*Crossing Paths* is the perfect example of the intellectual personal project born of a desire to meet people and learn from the experience both photographically and personally that has led to a body of work that is fast becoming a historical document of our time. This inspirational body of work also shows how a simple concept can produce work of photographic and social complexity.

The environment of the street is also the foundation of New York-based photographer Jake Chessum's projects *The Daily Chessum* and *Rubbish*. Jake is a portrait photographer who spends most of his time photographing actors, actresses, and musicians for a wide variety of editorial and advertising clients but his passion for photography and image-making has seen him develop projects that promote and illustrate his sophisticated, graphic visual language outside of the commissioned environment. *The Daily Chessum* is a daily updated visual blog upon which Chessum posts images he creates from his daily travels, from past work, and from non-submitted images from commercial assignments. The project therefore works as a traditional blog, but the personal aesthetic of the work transforms the blog into an online personal project based on observation. Chessum creates graphic compositions from the mundane bringing together of everyday typography, bold color, and connecting textures and patterns to create an ongoing language of the street. This intellectual personal project is based on a personal exploration

The point at which a project ends is when the final edit begins. Here Niall McDiarmid assesses some of the portraits created for his *Crossing Paths* project before deciding upon a final edit for publication as a limited edition, self-published book.

of graphic potential. *Rubbish* is both an online selection of images and a printed book, which Chessum has created as an offshoot project from *The Daily Chessum*, and which he has used as both a promotional marketing tool for his practice and a limited edition, collectable artifact.

# THE PERSONAL PROJECT: BOOKS AND EXHIBITIONS

Successful personal projects are produced by those who find interesting stories in interesting ways. They don't have to be unique stories, but like all good stories they need to be told well. They don't have to involve great expense and extensive travel as often the best stories are at the end of our streets, not at the end of an air flight. But if you find the right one for you and approach it in the right way, the personal project will become the spine of your photographic practice.

As I have outlined, the personal project has a great number of benefits to the twenty-first century professional photographer's career and practice. But once you have created your body of work you are going to want to show it to people and how you do this needs to be considered before you progress too far. Let me tell you why.

The majority of photographers begin a project with the same two end goals for the work—a solo exhibition and a published book—both of which can be realistic and appropriate destinations for the final work. However, few photographers or projects achieve these goals without a clear understanding of the commercial demands of both destinations before beginning the project. I have lost count of the number of conversations I have had with photographers who have completed a body of work with the intention of creating both a book and exhibition of the work, yet have completed no research into the reality of creating either or both. By this stage they have spent both time and money creating the work only to find that they were going to fall at the final hurdle as publishers express a lack of interest in their work, and the financial cost of staging a solo exhibition is prohibitive. If these are your end goals, you must understand how both work, and you must understand the alternatives.

# THE GOLDEN AGE OF PUBLISHING: THE PHOTO BOOK

We are currently within a golden age of publishing, independent publishing, self-publishing, and digital publishing; but not traditional publishing. The power of the publisher has been given to all, but there is a lot more to the art of publishing than creating a single book. The advent of digital publishing has opened as many doors for the professional photographer as digital capture. Printing has never been less expensive or more available. As a result the proliferation of photo books over the last few years has been prodigious. Companies such as Blurb have brought a professional approach to the online digital self-publishing environment and created an obvious solution to photographers looking to transform their personal images into traditional book format. For many photographers this is a perfectly adequate final solution to a project. They will pay for a small number of books to be produced to send out to valued clients, and place the title with an online bookstore for sale on a print-on-demand basis. However, this will not provide you with a revenue stream without a large established online community to sell the book to, and even then there is no guarantee that the prospect of this type of book will excite members of that community enough to make a purchase. The photographic book-buying community has grown more sophisticated and increasingly demanding, as more and more titles have become available via the very digital platforms that have fired the interest in buying collections of photography in the masses. The digital online book can provide an excellent solution as a platform to show clients a collection of work or as a promotional, marketing gift for existing and potential clients, but this solution is based on preconceived formats that may not be appropriate for your work or project.

Traditionally the concept of publishing your own work and paying for it to be published has been titled "vanity publishing," and viewed as an option only adopted by those whose work has been rejected by traditional publishers, and is therefore deemed to be of inferior quality. This is no longer the case and self-publishing is not only an acceptable practice for photographers it is rapidly becoming a global community in its own right. This community is embracing the concept of the online digital book, but also promoting books created across a broad section of printing, binding, construction, and paper stocks. Through this experimentation in production and the finished artifact, a personal project can develop from a simple book of images into a piece of work, which further develops the concept and the work created. The construction and production of the book will now alter how it is perceived and engaged. This experimentation is creating

finished books with a collectable value and therefore an inherent reason to purchase them, beyond collecting a series of images. The addition of a numbered limited edition and/or limited edition print as part of the final book aids in creating this perception of a personal project book as a collectable. This then becomes a more exciting prospect to the potential photo book collector. It also becomes an artifact to enter into photo book shows and competitions.

In many ways whatever format you decide upon for your published book, the act of printing the book is the easiest stage. The most difficult, and the one most often forgotten about, is distribution. There is no point in printing hundreds of books that spend their lives getting dusty under your desk. You are going to want people to see them and possibly sell them via traditional booksellers. However, you cannot expect these sellers to accept your books purely because you want them to. Most of them will have limited space to stock and display titles and will need to focus on selling those with an existing audience, to ensure they maintain a profitable shop. There are independent sellers in most large cities that specialize in art, design, and photography books and they are often open to talking to self-publishers, but even if they like your book and agree to stock it they will only take two or three copies at most initially. They will also want to know the price of the book and what their share of the recommended retail price will be. Never forget that publishing is a business and you will be expected to treat it as such. The simplest way to sell your book is from your website. Your success in doing so will directly relate to how successful you have been in creating your online community and engaging them throughout the process of creating the project and subsequent book.

I have focused on the process of self-publishing as a logical outcome of personal projects and not mentioned the possibility of a major traditional publisher publishing your project. Photography books—even those created by the great names of photography—rarely achieve a large number of sales. Most sell only in the low thousands and from an economic perspective they are a financial risk. This is why many established publishers will look for a contribution to the cost of printing from the photographer. This contribution is also a factor in deciding whether or not the photographer will be allowed to have the size, pagination, and quality of paper stock that they require.

**blurb**

## Make your own book to share or sell

Join Today   Sign in

Search Blurb

Why Blurb   Photo Books & More   Make Your Book   Sell Your Book   Support   Bookshop

### Beautiful print+ebooks.
### Made by you.

**1** Start your book or ebook today with one of our book-making tools.

**2** Add photos, artwork and text. Get inspired.

**3** Order one book or many. Prices start at just £1.99.

Editorial Stories
| Michael Creagh

Add sound and video to your ebook.

**Make a Book**

## HOME  LIBRARY  SCHOOL  BOOKCLUB  EDITIONS  STUDIO  SHOP

SPBH BOOK CLUB
VOL. III BY CRISTINA DE MIDDEL

APRIL 2013

## BOOK DU JOUR: UNTITLED BY LUIS DOURADO

**SELF PUBLISH, BE HAPPY**

ABOUT
PRESS
CONTACT US
NEWSLETTER
EVENTS
FACEBOOK
TWITTER

### CATEGORIES

BE HAPPY ♥
BE IN LOVE
BOOK DU JOUR
BOOK TO COME
CLASS OF 2012
EVENTS
NEWS
PHOTOZINE COMPETITION
SELF PUBLISH, BE HAPPY ♥
SELF PUBLISH, BE NAUGHTY

A selection of home pages demonstrating the growth of the self-publishing community online and the various forms of engagement available to the photographer hoping to see their work in book form reviewed, distributed, and sold.

THE INDEPENDENT PHOTOBOOK

THE INDEPENDENT PHOTO BOOK ANNOUNCES INDEPENDENTLY PUBLISHED AND/OR PRODUCED PHOTOGRAPHY BOOKS OR ZINES, WHICH ARE NOT AVAILABLE VIA AMAZON OR OTHER STANDARD OUTLETS.

28 MAY 2013

Joachim Schmid - Menschen des 20. Jahrhunderts

Menschen des 20. Jahrhunderts
Joachim Schmid
16 A4 booklets in a box, 24 pages each
edition of 25 copies
digital offset
120 €

"The photographic project Menschen des 20. Jahrhunderts (People of the Twentieth Century) began as an experiment to see if there was any logic behind which newsworthy photographs make it to the front covers of newspapers, and how this may correspond with the diversity of photographs of the respective event. Created between August 1985 and March 1987, the final collection consists of fifteen chapters, each containing repetitive images of a particular person that, for some reason or another has made it onto the front covers of German newspapers."

ABOUT THIS BLOG

The Independent Photo Book announces independently published and/or produced photography books or zines, which are not available via Amazon or other standard outlets. The blog's founders and editors are Jörg Colberg and Hester Keijser.

HOW TO SUBMIT BOOKS/ZINES

Generally:
- We only accept announcements about existing print books or zines (strictly no fundraisers)
- By "zine" we here mean not regularly published magazines, but rather one-time publications (which are often xeroxed/cheaply printed and stapled, thus resembling a magazine)
- There is no selecting, editing and/or curating involved
- At the time of the listing, the book/zine has to be available (no "sold out") so people can actually order it online
- no repeat announcements or "special offers" or "30% off" sale announcements
- we only list books or zines that cannot be bought via

## The Photobook Club

Home    Reading List    Get Involved    About    Resources    Meet-ups    The Future of Photobooks    Box of Books

### Where is the Box?

As the box of books travels around the world, it will be stopping off at different Photobook Club branches along the way. Check here to see where the box currently is and where it is heading to next.

If it is near to you and you would like to get involved in discussion then you will be able to attend the planned meetup which will host the box.        .

If there is a group of you who are interested in holding your own event around the box of

**About The Photobook Club**
The Photobook Club aims to promote and enable discussion surrounding the photo book format. In particular looking at old, rare and influential photography books from the 20th century onwards.

The Photobook Club is run by Matt Johnston.

Some publishers, Steidl in particular, buck this trend and follow a different publishing logic, focusing on the photographers demands over obvious confirmed financial reward. Usually these are projects created by established photographers, or projects that have already established a reputation for themselves at festivals and through exhibitions. The chance of a mainstream publisher taking on your project is slim, not impossible, so ensure that you do not rely upon mainstream publishers as the answer to your publishing requirement.

# THE ART OF EXHIBITING

A book is an obvious end for a personal project but so is an exhibition. Photographic exhibitions have been mounted since the earliest days of photography and they are a traditional platform for showing and selling work. As with every aspect of photographic practice, the digital revolution has opened up new possibilities within the exhibition environment.

The options for printing are myriad. Photographic prints no longer have to be on paper nor framed and placed behind glass. They can be on metal, plastic, or projected on walls or on the outside of buildings. They can be pasted on walls, mounted onto foam board, back lit within light boxes, and, in fact, be presented in any way or place that you want to exhibit. The photographic exhibition no longer has any rules to constrict its format; it is an organic form that responds to the work to be shown, the intention of the photographer behind the work, and the location in which it is to be shown. When it comes to presenting your work within an exhibition environment you need to be open-minded, and you need to research what other photographers are doing and why.

A great way of doing this is to follow galleries, festivals, and photographers with a reputation for exhibiting their work on Twitter. They will be talking about what they are doing so what better way to learn how to engage with and build your own audience than by learning from the success and mistakes of others? It is also worthwhile looking on Twitter for requests for submissions of work by national and regional photography festivals. You should also consider engaging with the people involved in curating and programming these festivals, ahead of the actual events so that they can start to follow your progress and feel connected with the work you are creating. That feeling of connection will always

create a "feel good" factor about you and your work and put you into a positive position when the event is compiled. Creating an exhibition is always easier if you have a network of people to work with on promoting, marketing, and creating the actual event and there is no better place to network than online.

Of course the physical exhibition is an established form, but it is not your only option. You could create an online exhibition to showcase your finished project. This can be part of your existing website or you could create a specific URL and site for your project linked to your website. The choice is yours and should be made on the appropriateness of the project material to your main body of work. Either way and even if you create a physical exhibition, an online exhibition is an essential shop window for your work.

# PERSONAL PROJECTS VERSUS INCOME

The concept of the personal project raises one particular thorny issue for a lot of established photographers with careers based on creating images to commission only. The issue is that of working for free, creating images without payment. If I think back ten years, those photographers could rely upon the phone ringing. They could rely on work creating work. What I mean by that is a successful photographer would aim to work for a client, have that work seen, and then pick up the next client, or next commission on the successful conclusion of that work. There was not the need for commercial photographers to create personal work at that time, they did it if they wanted to, but it was not a commercial necessity as it is today. It was these photographers who initially saw the personal project as "working for free" and they had no intention of doing it. Ten years on and the concept of working for free has definitely changed.

I would like to share with you an experience that happened to me a few years ago. I had been approached by an advertising agency to shoot an annual campaign for one of the agency's important clients. The agency liked my work and the client liked my work. They both wanted me to shoot that year's campaign, and after I had met with the agency and discussed the extremely large budget and fee I was keen to work with them. All was agreed and we were ready to start discussing shoot dates when I received a phone call from the agency to say that the photographer who had shot the campaign the previous year had heard that he would not be shooting it this year. He was not happy to lose the

commission and therefore had offered to shoot this year's campaign for free, in short he wanted no fee. Obviously this appealed to the agency—I have no idea if they intended to pass on this saving to the client—and as they explained to me, they were now in a difficult position, so would I also shoot the campaign for free? Obviously they would prefer that I shot the campaign, but what did I think? I needed no time to consider the situation. I thanked them for considering me for the campaign and declined their offer to work for free. I have never worked for that agency or their client. But what I do know is that the photographer who offered to work for no fee was definitely working for free. It is also a perfect illustration of the brotherhood of photographers.

Creating a personal project or creating personal work is definitely not working for free and should not be misunderstood as such. It allows photographers to re-connect with that spirit that was within them all when they started taking photographs. It is a way for photographers to tell stories they feel need to be told and it is a process by which they can develop and evolve their personal visual language. The personal project is also a vehicle with which photographers can exist as professional photographers even when the phone has stopped ringing. If you have never considered working on a personal project or if you have found them difficult to begin or progress with, below is a list of important factors that you will need to consider to ensure that your personal project is both fulfilling and successful.

## How to Create A Successful Personal Project
▼

1. Find your story. Make sure that it is personal to you, that you have a unique voice to tell the story in, and that you are interested enough to spend an appropriate amount of time and effort to see it through to fruition.

2. Do not be overly ambitious. Be realistic about what you can achieve on the basis of the time and financial commitment you are going to be able to devote to creating the project.

3. Do your research. Find out if other photographers have tackled the subject you are planning to photograph. Look at how they did it, what the outcomes were, and how it was received. Then ensure that you do not repeat the same approach.

4. Build your online community as you are working on the project and keep them informed of its progress with images and information about how you are creating the project and the process you are going through.

5.  Be patient. A worthwhile personal project is not going to come together in a few days or weeks.

6.  Consider using audio and moving images to add both context and additional narrative to your storytelling.

7.  Research appropriate self-publishing options for your project and engage with the photographers who are already involved with the photo book self-publishing community.

8.  Try and attend talks and workshops being given by fellow photographers working on personal projects.

9.  Consider working with a journalist or writer at some point during the process of creating your project. Inevitably you will require text to accompany your images, or to include in your book, or on your website to provide context and information. This text needs to be as professional as your images, so get a professional to create it.

10. Stay true to your vision but be open to your project evolving into unexpected areas. The excitement always lies in the choppy waters.

# NOTES

1. Bleasdale, Marcus and Swain, Jon. *One Hundred Years of Darkness*, 2003, London UK, Pirogue PR
2. Bleasdale, Marcus. *The Rape of a Nation*, 2010, Amsterdam, Mets & Schilt Publishing

# THE VALUE OF THE IMAGE RECONSIDERED

**I WANT TO START THIS CHAPTER** with a question guaranteed to provoke debate. Does the photographic image have any value in the twenty-first century? Before you rush to respond let me first provide some context for a potential answer.

The digital revolution and the advent of digital capture has democratized photography and made an expensive hobby and professional vocation into an inexpensive form of visual communication for the masses. The taking of photographs no longer requires expensive specialist equipment and serious thought about the financial implications before the camera is loaded and the shutter is clicked. A roll of film containing twenty-four exposures no longer needs to cover a plethora of family events. As a result the photograph as an object created by the action of pressing a button has been devalued. More images were created in 2012 alone than the total taken in all of the years since the invention of photography nearly two centuries ago. An estimated 100 billion photographs were shared on Facebook between its launch in 2004 and the end of 2011. By April 2012, its users were posting photographs at the rate of 300 million per day. These numbers are even more staggering when you consider that an estimated 11 billion photographs have been uploaded to image-based sites such as Flickr and Instagram since their launches. The devaluing of the photograph has also devalued its creation. The image has been devalued, the process of capturing the image has been devalued, and the role of the professional photographer has been devalued. However, the power of the image has never been greater.

Why? Because we are now witnessing the return of a pre-historic form of communication and its creator. The caveman is back and the image is once again a main form of expression. However, twenty-first century cavemen don't draw on rough-hewn rock, they are digital cavemen using technology to cross language barriers. The only connection between the past and the present is the power of the image as a universal language; our platform of digital communication relies upon the delivery of concise information to achieve maximum impact. The single image allows us to achieve exactly that: a new, universal, image led vocabulary has been born. In this respect the digital image has established the photograph as being central to all our lives. But how can we as photographers ensure that the professionally created image maintains a perceived value within this new vocabulary?

As with every element of the new landscape of professional photography, understanding the value of the image requires a global understanding of both the economic and the image-making environment. The first level of this understanding comes through the acceptance of the reality of what a digital image is. In essence it is code, nothing more and nothing less, a series of ones and twos constructed to perform a task of image capture.

At birth the digital image is by its nature cold and methodical, an algorithm of composition. It does not embody the magic and mystical qualities of an analog image captured onto film and revealed through a specific potion of liquids and chemicals. Therefore its intrinsic purpose for many is no longer that of the treasured artifact. The digital image does not feel special. Our relationship with the image is now based on our relationship with technology.

For example, we are emotionally connected to a handcrafted piece of furniture handed down through generations of our family, but not to a plasma screen television. One is associated with craft, the other with technology. This change in relationship with the digital image from the analog image is also relevant to professional photographers, many of whom will only view their images on screen and rarely as a finished, self-created print.

Digital capture has created a dichotomy for the photographer. It has opened up creative opportunities and freed us from the financial constraints of analog creation, but it has also forced us to reconsider how we value our work and practice. It has also placed us into the unexpected position of gatekeepers of our work, protectors of its unrestricted, unregulated, online life. These may seem to be two unconnected aspects of today's professional photography practice but they are in fact intrinsically linked.

# THE NEW WORLD OF COPYRIGHT

The one word guaranteed to anger, upset, frustrate, and confuse professional photographers is the word "copyright." The world of copyright is based on legal statutes and proven cases but national, and not international, law define it. This is the central problem with copyright for photographers today whose careers and digital platforms are global. I have no intention of attempting to enter the world of copyright or beginning to outline or

explain it to you, as most countries have excellent professional associations with experts who will be able to do just that with local and national knowledge. However, I do want to address some of the most common considerations that photographers currently face wherever they are based.

The first consideration is the reality of working for editorial clients. The world of publishing sets its own rules and the deal is simple. It involves a direct yes or no answer from both the client and the photographer. The majority of publishers will expect you to sign over all ownership of your images to them in perpetuity across all of their existing publishing platforms and for any that may be invented in the future. In short they will want to own everything, to use it everywhere, anytime they want. The fee will invariably not be large and some publishers will offer to syndicate your images for you as part of the sign over, at rates they negotiate, for a percentage they will control. You don't have to work for them but if you do you will have to accept their terms, pure and simple. The value of your images is therefore defined by the value of the commission. You will usually be allowed to use them on your own website and for personal marketing, but nothing more than that. This approach to commissioning may not be appreciated by many photographers, but it is a cold, hard reality and one with which you will have to deal.

The second consideration deals with the concept of orphan images. As I have previously mentioned the copyright of images can be confusing for photographers to understand and it is certainly not something about which many clients have anything but a passing understanding.

Many people actually believe that if an image is on the Internet then they can download and use it however and wherever they wish. The Internet is free to access, so everything on it must be free, right? Wrong! Even though people know that this is wrong they still behave as if it wasn't, presuming that they will never be caught. It's online shoplifting and you are going to have to try and prevent it happening. The easiest image to "shoplift" is an "orphan image." So what is an orphan image? It's one that has no embedded meta-data or obvious details as to who created it and/or owns the copyright and is therefore very hard to track or trace if it has been used without permission. Orphan images are to be avoided.

# PROTECT YOUR IMAGES ONLINE

You need to protect your images online, or at the very least understand how they are being used. One of the most basic actions you can take to protect your images is to post them as low quality versions on social media sites and on your website. A high resolution image is exactly what an unscrupulous or ill-informed downloader is looking to exploit. Your online images don't need to be bigger than 640 to 800 pixels on any long side and 72 dpi. This image size is good enough to look at online, but not good enough to print commercially as quality commercial printing usually requires a minimum 300 dpi image size. Get your file sizes right before posting your images and you are on your way to protecting them.

The simplest actions can often be the most effective ways of protecting your images. For example, you should consider using Exchangeable Image File data (EXIF) when creating your images. This is a simple procedure that allows your contact and copyright usage details to be easily incorporated into the image data, just as the shutter speed, focal length, and aperture are all stored within the file data. This means that as long as the website onto which you upload your images has not stripped out your EXIF data—and some do—it is possible for anyone to find out who owns the image. If you can't do this in-camera, software programs such as Adobe Lightroom allow you to add this information when you import the file.

However, the embedding of information into your images is just the beginning of the dark art of metadata, a complex and detailed process of incorporating information and keywords to help search engines locate your images. Accurate, commercially sophisticated, and detailed metadata is essential for photographers who are looking to place their images within stock agencies or to control their own syndication.

Simple key wording is also essential to control the use of your images online. As with all metadata the more specific you are with the keywords you use, the easier your images will be to find, so use details such as location, subject matter, and shoot dates, alongside your name to ensure that you are correctly credited if the image is re-used. Internet search engines rely on this information to source images when matching keywords inserted into their search panels, therefore the better your keyword data the better your relationship will be with your images, and the people who are using them.

I know that this may seem like the most basic of advice. However, just as I continue to see inappropriately written e-mails from photographers of all levels of greater/lesser experience, the same is true of how images are handled and protected. So if you are not looking after your images online, start now by getting the basics right and ensuring that your images are at least traceable.

Many photographers avoid the issue of embedding traceable metadata by watermarking their work so that their images become commercially unusable if downloaded. As with every area of reaction to the digital age of photography there are many opinions about how or whether to watermark your images. In reality, it's your call, based on your personal weighing of the pros and cons of doing so. If you do, you are adding an extra layer of protection to your work, but if you are heavy handed it can have a negative effect on your images and how they are perceived. However, if it's done with sensitivity, it can allow people to see your images while also letting them know who created them, and, of course, protecting them.

I was interviewing a student who wanted to join the university at which I teach and whose portfolio of images was very limited in scope and quality. I asked him if he had a website on which he had more examples of his work. He said that he didn't but that he did have more work on his Flickr page. While he sat in the interview we had a look at his page which featured more of his work and showed him as a much more competent photographer than his portfolio did. However, every image was covered by a watermark that obscured most of the image. I asked him why this was. He replied that he had read that every image must have a watermark and he had therefore followed that advice. Unfortunately, in following the advice he had forgotten about both the image and the viewer. Watermarks: handle with care.

The use of Creative Commons has freed a number of photographers from traditional copyright agreements to enable an enlightened form of image usage.

# CREATIVE COMMONS

If the use of watermarks and metadata are contentious issues they are but punctuation marks in a conversation in comparison to the firestorm that surrounds the practice of Creative Commons. Many online users see Creative Commons as being the natural extension of the free information access that the web is based on, while others see it as the end of professional photography and the paid for image, in effect an online copyright Armageddon. Even more have no idea what it is and haven't even heard of it. Whichever of these camps you may be in, here is a brief outline of Creative Commons and why it may be worth considering as part of your practice.

Creative Commons is a non-profit organization that enables the sharing and use of creativity and knowledge through a series of free legal tools. They provide copyright licenses that present a simple and standardized format to give the public permission to share and use your images, on whatever basis and conditions you specify, in effect allowing you to change your copyright terms from the default of "all rights reserved" to a more flexible "some rights reserved."

Confusion often comes with the use of Creative Commons if it is seen as replacing copyright. Let's be clear about this, it does *not* replace copyright. It does, however, work alongside traditional copyright, enabling you to modify your copyright terms to best suit your approach to placing your work online. If you want to give people the right to share your images, use them, or even build upon the work that you've created, you could consider publishing that work under a Creative Commons license. For example, you can choose to allow only non-commercial uses for your images that would protect the people who use your work from copyright infringement, as long as they abide by the conditions you have specified, while also protecting the same images from commercial use abuse. This could also be useful to you if you are looking for music or moving image footage to use in your own work. In this respect Creative Commons can be of mutual benefit to the creatives who choose to adopt its copyright model. The other benefit of Creative Commons licensees is that they work with copyright experts around the world to make sure that their licenses are legally solid and globally applicable, therefore avoiding a number of potential national copyright issues.

# NEW WAYS OF FUNDING

Protecting your images and adopting a responsible approach to the copyright you apply to them are obvious approaches to placing a personal value on your images that you can directly affect. But there are other ways in which you can gauge the perceived value of your work from a much wider perspective. Crowdfunding and crowdsourcing are two recently developed platforms through which you can progress your work, engage with and enlarge your online community, and receive an indication of what people feel your work is worth.

The concept for both is simple. You post a project that you would either like to have financially funded or for which you would like help from fellow creatives with the specific skills you need to complete the project. There are a number of sites specializing in both forms of funding that you can post these projects on, and each has their own rules as to how you can receive your funding. The bottom line is that the better you are at marketing your project, the bigger the community to which you can appeal; the more interesting your project, and the more compelling your work, the more chance you will have of achieving the funds you require.

The use of crowdfunding websites has become an essential enabler of independent photographic and film-based projects.

A number of photographers and filmmakers have been particularly successful in finding funding for their projects through crowdfunding over the past few years. Unfortunately the success of those projects has caused a glut of weak concepts to flood the different platforms, resulting in an inevitable loss of enthusiasm among those previously willing to support projects. Crowdfunding fatigue is starting to become an issue, and while I was writing this book one of the photography-specific sites entered insolvency. Whether this situation will continue or improve is impossible to predict, but it is a perfect example of the speed at which the Internet moves, consuming concepts at a previously unimaginable speed. At the time of writing both crowdfunding and crowdsourcing are concepts worth exploring, but there was also a time when MySpace was the place to go.

# TAKING STOCK

My own involvement with the world of stock photography began in 1999, a pivotal time for the industry. I had been working within the editorial environment as an art director for thirteen years when I was asked to take on a senior position within a global stock agency with responsibility for explaining what would be the future of stock photography. A difficult task you may think for somebody who had never worked within the stock industry, and you would be right.

However, at the end of the 1990s the future of stock was obvious to anyone who was in the position of using it. Stock had to get better, it had to raise its game, become more contemporary in feel, more adventurous in concept, and, most importantly of all, raise its perceived value. In 1999 stock looked and was cheap. Like a down at heel supermarket selling bankrupt, out-of-date goods. The introduction of royalty free images and package deal CDs of images that could be used repeatedly had reduced the majority of stock libraries to bargain basement offerings. This resulted in agencies constantly forcing the prices down, desperate for a sale.

Getty Images changed the game. Led by its founder, Mark Getty, they traveled the world buying agencies (both large and small and many with obsolete analog archives that needed to be digitally scanned or scrapped), and rebranding them under the Getty banner. They sold images cheaper than anyone—upsetting many photographers in the process—and created new levels of work and platforms within their portfolio. Getty's intention was to own the marketplace from the cheapest to the most expensive stock images you could buy from all photographic genres. Today, although they are not the only player in the marketplace—companies such as Corbis and Shutterstock have similar business models—they are the dominant force not only in stock images but also in providing moving image footage and photographers for commission. Stock is no longer the budget supermarket it once was—it is now the shiny, new, online shopping mall catering to all tastes and budgets.

That's from the client's perspective, but what about from a photographer's viewpoint? Is it possible to still make a living from supplying stock images, and if so how can you ensure that you understand the stock business and play it to your best advantage?

First it's important to understand that the stock game is primarily a numbers game. The more images you place with an agency the more chance you will have of selling one, two, or, hopefully, more. But is it really that simple? Well, yes and no. The most important consideration of stock photography is the client. What they want, what they need, and what they are willing to pay for an image. As such the photographer is the supplier of content to meet those needs and the client defines the value of their images. This has always been the case with stock images but today that client is far more demanding on both price and quality. This reality can be disheartening for a lot of photographers—and reason enough to not work within the stock environment for many. However, if this is not an issue for you, and you are willing to play by the stock rules, there is a possibility you will do well.

You can enter the stock market in a number of ways. The base level of entry is through an agency that will accept any work from any photographer—enthusiast or professional—without model, child, pet, or property releases for anything you place with them. This is the photo equivalent of a pound or one dollar shop. Your images will be sold cheap and you will be held responsible if there are any legal issues with the images you submit. This area really is a numbers game and your metadata will be key in ensuring that your images appear in as many relevant searches as possible; so do some research into which are the

agency's weakest and strongest areas, in order to ensure that the work you submit will give you the best chance of a financial return. You should also be aware that submitting images to an agency of this kind might be considered detrimental to the perception of your work by certain clients. Many photographers use pseudonyms for their work and this may be a good option for this area of stock.

The clever way to approach submitting images to stock is to respond to their "wants" list. Most agencies produce these based on enquiries from clients that they either have not been able to fulfill, or on an informed sense of what the market might be requesting in the near future. They are also used by the agency to build image archives in areas in which they know they are weak. These lists are available to all photographers—Getty even has a Twitter feed devoted to their daily wants—but they should only be seen as starting points from which to create imaginative creative solutions.

Responding to "want lists" requires an understanding of what sells, hard work, and quite a lot of faith in your abilities to respond correctly to the wants. But don't get carried away and see this as commissioned work—it's not. This is unpaid work that may never pay out, so it is not for the faint hearted or for those looking for a quick return on investment. Check out the technical and submission requirements for each agency you decide to submit to before you start shooting to ensure that you are fulfilling all of the agency's rules of engagement. This includes shooting on the correct approved camera that most agencies give information about on their websites under the submission requirements.

These rules of engagement can include a portfolio review of your work to see if the agency wants to accept images from you; and these agencies will usually sell your work for premium prices to premium clients. These are the agencies about which I spoke earlier, who are changing the above-the-line advertising commissioning environment by supplying high quality images produced by creative photographers to clients looking for images, that remove the so-called "risk" of commissioning. They are also the agencies that are looking for the most innovative conceptual work completed with the highest post-production attention to detail. As a result this work requires the biggest financial and creative investment from the photographer. As I have also mentioned there are some photographers who make substantial personal investments to create work for these agencies based on their informed knowledge of both the agency and client needs. The financial risks of creating this kind of work are high but the returns can be substantial.

Stock and syndication photography require imagination, perseverance, and self-motivation. Wherever I am I always look for opportunities to create images that I can then place with a stock library or syndicate. These images are part of a large body of work I shot while at a wedding in northern Sweden. The house was attached to the main venue for the reception and while the official photographs were being taken I gained permission to shoot the house and secured property release forms.

Despite the risks stock photography is no longer a dirty word in the world of photography, nor is it looked down upon by those who previously saw it as an option only for those who could not get commissioned. Today it should be a serious consideration for photographers, whatever genre of work they are creating. But let me dispel two common misunderstandings: stock should not be seen as an easy option or as a dumping ground for all of your unwanted work. Making money from stock is going to involve understanding that clients' needs are often simple and frequently repetitive. However, they are always looking for creative and innovative visual approaches to the most basic of subjects.

**Stock agencies regularly issue "wants" lists to photographers. Getty Images has recognized the immediacy of Twitter as an efficient and rapid platform on which to deliver this information.**

# SYNDICATING YOUR IMAGES

Stock photography is one way of creating a value for your images. Another, which is sometimes confused with stock, is syndication. Syndicating your images is a process that allows you to make a secondary profit from your commissioned images, and sell your personal projects through an established agency, or personal syndication. But, as with every other area of photographic practice, syndication has changed dramatically thanks to the new landscape of digital capture and communication.

It is important to understand
the role of the syndication
agency in a photographer's
distribution network,
and its specific areas of
specialization.

Syndicating commissioned images has traditionally been an excellent source of income for editorial photographers. You get paid to take pictures, with your costs reimbursed, you maintain the copyright and—often after a three-month period—syndicate them under a series of licenses based on usage, again and again. It's a great business model and revenue stream; the only problem now is that more and more editorial clients will require you to hand over the copyright as part of the commission, leaving you with no images to syndicate. However, this does not have to mean that you cannot create images for syndication. Whereas stock photography's lifeblood is the single image, syndication's is the narrative. If you can supply a visual story with accompanying text your chance of having your work picked up and run as a whole are greatly improved. In the same way stock requires research to ensure that you are shooting the right content to sell, syndication requires a similar approach and aptitude to establish what is in demand. This research is not confined to the type of stories you are going to shoot and how but includes finding the right agency to sell that subject matter.

For example, I work as both an interiors and celebrity portrait photographer and I also shoot personal projects. Therefore I have an agency that syndicates my celebrity portraits in London, another one that specializes in syndicating my interior work, also in London, and a stock agency based in New York that takes individual images from my personal projects.

Each agency is a specialist in their area and has a client base right for the work I place with them, which is why I chose to be represented by them. As with stock, syndication can be a viable option for photographers who have copyright of their images; but even if you do not have control of your commissioned images you can still make use of the syndication model.

When I am not shooting commissioned interiors. I will shoot interiors stories that I source and shoot purely to be syndicated. I always ensure that I have the correct permissions, model, and property releases in place and write my own text to accompany the images. I then place them with the agency and leave them to sell the story within an international marketplace. Digital capture means that I will have incurred very little cost outside of traveling to the location and the story will be sold repeatedly across different territories. Syndication not only places a value on your images, it allows them to be constantly re-valued over an extended lifespan.

The growth of online sites selling contemporary art photography has made collecting easier and more affordable, while giving photographers outlets for work that would not have been seen by a global audience. This has, in turn, encouraged many photographers to enter an area of practice that would previously have been seen as limited in revenue generation and profile recognition.

Search          Log In          Not Registered?

▶ Collecting Category          ▶ Search by Artist          ▶ Advanced Search

**View All Artworks**
**View Lots Sold**

artnet Home  >  artnet Auctions  >  Photographs

**Style**
Abstract
Asian Contemporary
Conceptual
Contemporary
Emerging Artists
Figurative
Mid-Century Modern
Middle Eastern Contemporary
Modern
Pop
Urban
Vintage Photographs

**Photographs**

artnet Auctions' team of experienced photography specialists is continually searching for the most iconic artworks. Record-breaking prices include Robert Mapplethorpe's 1984 silver print, *Ken Moody and Robert Sherman*, sold on February 2, 2011 for... **Read more**

| All | Auction | Purchase Now |
|---|---|---|

Sort by [Ending Soonest ▾]     Show [9 Lots ▾]          159 Results     Page 1 2 3 4 5 >

**Media**
Design
Paintings and
 Works on Paper
**Photographs**
Prints and Multiples
Sculpture

**Price US$**
Up to 5,000
5,000–10,000
10,000–25,000
25,000–50,000
50,000–100,000
Above

**Era**
Pre-War
1940s–1950s
1960s–1980s
1990s–Present

**Ending**
Ending Today
Ending this Week
Newly Listed
Purchase Now

**August Sander**: *High School Graduate (+2 others; 3 works)*, 1926
Silver Print, Gelatin silver print
**Opening Bid**  US$9,000 €
**End Time**  4 hours, 3 minutes
Wednesday, December 11, 2013, 10:30 a.m. (EST)
**View Details ›**

**Marilyn Bridges**: *Three Pyramids of Giza, Egypt (+2 others; 3 works)*, 1984
Silver Print, Gelatin silver print
**Opening Bid**  US$2,000 €
**End Time**  4 hours, 53 minutes
Wednesday, December 11, 2013, 11:20 a.m. (EST)
**View Details ›**

**Hiroshi Sugimoto**: *Palace, New Jersey*, 1978
Silver Print, gelatin silver print
**Current Bid**  US$20,000 €
**End Time**  5 hours, 18 minutes
Wednesday, December 11, 2013, 11:45 a.m. (EST)
**View Details ›**

# THE RETURN OF THE ARTIFACT

So far I have spoken about the digital image as a purely digital entity or as a commercially printed outcome. However, the foundation of photography has always been the photographic print. Despite, or perhaps due to, digital capture, it could be argued that the print is more important today than it has ever been throughout the history of photography. Why? Because it is one of the last tangible links to the analog days of photography, and because the photographic print provides us with a photographic artifact that is not displayed as a back lit "ultra image," a digital stained glass window. The book, the print, the artifact are important to photographers; they are physical evidence of our craft.

The photographic print is a collectable and, therefore, has an intrinsic value to anybody who wishes to own it. From a commercial perspective, a client will rarely request a print for reproduction, and those photographers still working within an analog practice will often provide the client with a digital scan of the final print.

Therefore the photographic print today is created for the sole purpose of display, either within a print portfolio, print box, or on a gallery wall. This change in the fundamental use of the print has reduced the number of high quality prints in circulation and placed the print within a new context—that of artwork—but this new context comes with associated problems, as well as benefits.

Let's deal with the benefits first. People are buying and collecting photography, they are willing to pay for work, which in turn means that they are taking photography seriously as a creative form. This has to be good. However, it also means that photographers need to take the production and presentation of the prints they are hoping to sell equally seriously. It also requires them to understand some fundamental practices of the contemporary art photography market.

The first of these is the practice of creating editions. When it comes to pricing your prints you will of course want to consider the quality of print you are having made—particularly its archival qualities—and your financial investment in the production and presentation of the print. Unfortunately, that is where many photographers' understanding of how to price a print ends. They decide on a price for the print and try their luck achieving that price. However, by doing this they completely misunderstand how a photographic print

is priced in the contemporary photographic art market. The truth is that the value of your print will be determined by its rarity and that is something that you can control. This is how.

The concept of the "edition" is based on how many examples of a particular image are available at a particular size, on a chosen paper stock, and created by a specific printing process. The number of prints within each edition is completely up to you but obviously the fewer prints there are in an edition the more valuable they could be. Therefore the same image could be available within a series of different editions at different prices. This is how you control not only the value of the image but the access you give people to your work across a series of different price points.

The lowest price point should be that of the "open edition" print. This is a print that is unnumbered and unrestricted in its reproduction, and should therefore be seen as an entry point purchase to encourage novice and seasoned collectors willing to take a chance on a young photographer to start purchasing your work. By adopting the edition process you will not only bring understanding to the purchasers as to how you have priced your work but also to the process of creating photographic prints and collecting them. It really is a win-win situation and one that you cannot afford to ignore. You may also wish to extend the concept of limited edition prints to your self-publishing practice by offering a print from any book you publish as an added incentive to purchase the book at a marginally increased price. Again this encourages people to see both your book and your print as a collectable artifact and encourages them to see you as a photographer worth investing in.

Understanding the importance of creating editions is the foundation of beginning to price and sell your work. However, the most important question to ask is: How do you decide on the price for any print in or out of a limited edition? Well, this is where things can go very wrong and a big dose of humility needs to be taken before any prices are set. Humble pie is a regular meal for any photographer. Without the appropriate level of self-realization, most photographers are overambitious when pricing their work and unrealistic in their expectations of sales. Don't put Ferrari prices on your work until you have the profile, quality, and collectability of a Ferrari.

This lack of market understanding is particularly true of young photographers leaving higher education. The basic economic reality of selling is that three prints sold at $100 each is a more likely outcome than one print sold at $300. You get the same income, but in a different way. You are also opening up the possibility of three people buying more of your work, rather than just one. The pricing of photographic prints, images, and related products is all about this basic economic understanding. It's no different from selling bananas. Have a good product, present, promote, and price it right and people will buy.

In a world in which the photographic image has been so devalued, the photographic artifact has assumed a new and increased value, while the power of the image has assumed a digital, global, communicative power available to all. This leaves one basic and important question for the photographer to answer. What is my value as a photographer in this new landscape?

To begin answering this question you have to understand the importance of investing your images with a perceived financial and marketing value—as well as understanding how to protect that value. This is the foundation of understanding the value of the images you create and therefore defining your value as a photographer. This definition will provide you with the foundation you need to become a twenty-first century photographer. What is your value? Your value within the new landscape of professional photography will be defined by how you choose to respond to the new challenges it presents. However, the marketplace in which you place your images—as has always been the case throughout the history of photography—will define the value of your work and the success of your photographic practice. The difference is that you now need to include the definition of the professional photographer, and the importance of the paid for image. You can no longer expect both of these factors to be assumed, respected, or understood.

The concept of the artifact is one that is open to many varied interpretations, so to help you to create your own understanding of this term of reference, when applied to the photographic artifact, I have compiled a list of considerations for you to ponder to help you use this term with confidence and accuracy when discussing your work.

## How to Engage with The Concept of The Photographic Artifact

▼

1.  The photographic artifact is most often seen as being the photographic print or a tangible photographic product, such as a book.

2.  Understand the reasons for the use of the word "artifact" in a landscape of inbuilt obsolescence and non-tangible digital capture.

3.  The use of the term "artifact" implies a sense of historical importance and therefore an implied value not only culturally but also financially.

4.  Do not feel that the word "artifact" is only applicable to work created within the contemporary art market or that it exists solely within dusty museum archives. As with so many areas of the new photographic landscape, the adoption and re-interpretation of language is important in providing a new context for your work.

5.  Ensure that you understand what you mean by the term "photographic artifact" before using the word in relation to your images. If you are questioned as to why you are using it, you will need to provide a convincing argument.

# THE IMPORTANCE OF THE MOVING IMAGE

**THERE WAS A TIME NOT SO** long ago when the moving image was the big digital elephant in the corner of the photography room, never to be mentioned, and in some rooms it still is. Making films, shooting video, creating moving image, call it what you will—but don't mention it. Keep it quiet and it might go away: after all we are photographers not filmmakers, aren't we? We make still images—that's what we get paid for doing—why should we consider doing anything else? It's not our job. By now I'm sure, having got this far into this book, you will have realized that this is not—and has never been—my approach to the possibilities that the moving image offers the photographer. I'm more than happy to not only mention that elephant, but to bring him into the middle of the room and make him a center of conversation.

I have already outlined the technical digital innovations that have taken place over the past few years and brought about what is creatively possible for us to achieve in our image-making today. I have also explained how the availability of faster and wider broadband widths have created digital homes for the work created and why brands see the moving image as being so important to their online offerings. These are the fundamentals to understanding why the moving image is so important to a photographer's practice in the twenty-first century. But what is the everyday reality?

Let's get one thing clear. I am not saying that all photographers have to also be filmmakers (just as I am not saying that all filmmakers will become photographers!). I have heard many reasons and justifications for the lack of willingness to explore the possibilities the moving image offers photographers. But, while I do accept that it is not for everyone, I refuse to accept the lack of desire to experiment, learn, and grow.

## WHAT IS "MOVING IMAGE"?

Let's start to discuss the moving image with the semantics and accuracy of the language of the practice in which we are engaged. I have already discussed the anachronistic inaccuracies of the terms "photography," "videography," and "filmmaking." Now I'd like to talk about the wider context of what we do. What we are working with and creating today is "lens-based media." This is a far more appropriate description for what we create, whether through digital or analog technology. If you are able to accept this, as I

*The New York Times Lens* blog is dedicated to photography, video, and visual journalism but the title has fully embraced the power of the moving image throughout its online presence.

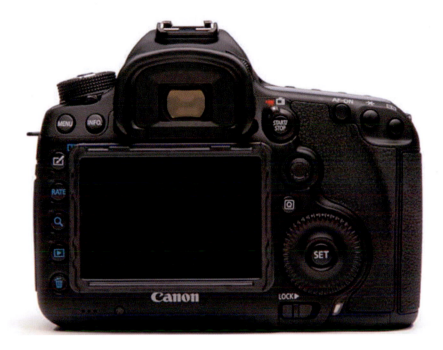

**Just to the right of the viewfinder above is a small red icon and a toggle switch above a start/stop button. How can something so small be so feared by so many photographers?**

am, then the concept of the moving or still image becomes redundant. The acceptance of this term then opens up all manner of possibilities for us creatively. We are no longer pigeonholed within a previously defined area of practice; we are free to create our own definitions.

The moving image is a natural creative progression for the photographer. We have always been capturing moving images, visual narratives; they just didn't move and have audio attached. Now that we have the tools to explore it would be a creative crime not to. And yet . . .

I often ask established photographers, "What's the only button on your camera you never use?" The answer is: the moving image button. Press that button and that is all you need to do to begin shooting moving image. Press the button. Now I am not in any way dismissing the complexities and skills required to create successful films, but I am attempting to remove the fear of that first step over the threshold of moving image creation. *Just press the button*–then worry about where you go next: the importance of audio, the art of editing, and the technical knowledge required to deliver the finished work in an appropriate format. These can all be learnt once you have overcome your initial fear.

When you begin I guarantee that you will be frustrated, confused, challenged, inspired, but, finally, informed. As a means of experimentation, digital sketching, narrative exploration, however you want to use it, is okay. You don't even have to show it to anyone. I have lost count of how many photographers have told me that since they started working with the moving image their approach to their still photography has been rejuvenated. They have found themselves reconsidering their work, both in practice and completion. Their work has grown and matured from this introspection in every aspect, from composition to lighting, from narrative to capture.

To fully understand how you should engage with the moving image and what level of engagement you should have, we need to explore the photographic world's approach to the moving image in more depth.

Many photographers have sought to merely wave at the moving image's approach from a distance. The result of this tentative flirtation is the still image-based slide show most often referred to as multimedia. The idea of this format is simple to explain. Based on a defined concept, the photographer creates a series of still images sequenced to reveal the narrative that the photographer wishes to illustrate. In addition to stills, the photographer will have recorded appropriate audio to support his narrative. This may consist of interviews, environmental soundscape, and/or personal reflections by the photographer. The resulting piece of work brings together the stills as a slideshow with the audio edited to the pace of the slide show. In effect it's a short film made of stills–a contact sheet with sound. It's a format that photojournalists embrace and is often seen on news-centered websites associated with newspapers and magazines.

These can be powerful evocations of the photographer's art and commitment to telling a story, but to describe them as mixed media is both confusing and inaccurate. The media being mixed is the photographic image and sound, that is a film. And yet those creating these slide shows have been some of the most reluctant to accept the moving image as a natural progression of their photographic practice.

I put this proposition to a room of experts in mixed media and photography at a seminar hosted by a respected international photographic organization. The response I received was unsurprisingly mixed. Some congratulated me for my bravery in making such a statement, others were nervous of my intentions, fearful that I was there to destroy the creative practice they had established for themselves.

From these responses I had two of my previous assumptions confirmed. One was that people are afraid to speak out against the preconceived categories to which they feel they must conform. The second is that fear of change produces a negative response to the advancement of creativity.

My answer to all of the responses was that we need to have accuracy of language to explain the different areas of creative practice, not so that we can conform to them but so we can converge the different areas of image creation and storytelling in order to establish our own personalized form of creativity and practice. This is the importance of the moving image to photography. It has made us think about: what we do; why we do it; the way in which we do it; how it is seen; and what is possible.

## MAKING MOVIES

The explanation as to why I believe that you should be engaging and experimenting with the moving image should be clear. What I am saying is being echoed by the commercial world. I previously outlined the reason for this when I described the new commercial environment for photographers, but I do believe that it is important to understand the influence clients have on the direction photography has to take.

The debate over the use of the term "mixed media" continues but to my mind moving image with audio is a film. *The Economist* creates its own films in-house, focusing on content featuring the magazine's editorial staff under the banner of multimedia. A leader in the field of the moving image for over ten years, ShowStudio.com does the same and commissions highly creative work under the banner of films.

# TEST

HOME
TEST PRESENTS
ARTISTS
ABOUT

**TEST was founded by the art director of *Vogue UK*, Jamie Pearlman, as an online platform for innovative filmmaking with a focus on fashion. It has now become an important example of the creative possibilities presented by mixed-media collaboration and creative risk taking, as well as a home for the new genre of conceptual narrative moving image.**

If you are convinced by my logic and explanations concerning the moving image and its relationship with photography, you will want to get started making movies. To do this, however, requires further understanding not only of the technical processes involved but also of the current moving image landscape.

Even the most cursory of glances at the current output of photographer-created moving image will clearly demonstrate that a large majority of photographers have struggled with two of the most important elements of the filmmaker's craft, narrative and soundscape. Photographers are visualizers who capture the moment in front of them, the decisive moment, not the decisive moments. Photographers enter situations and record them or create environments—alone or in teams of which they are often in sole control—whereas, filmmaking demands the skills of creative collaboration and, most importantly, creative and technical teamwork (this is particularly important in the areas of pre-production, post-production editing, and sound capture), none of which are the natural skill sets of the independent photographer, who feels the need to be holding the camera. The resultant moving image can therefore become nothing more than a series of beautifully considered images edited to an existing music soundtrack. In effect a photographic music video. This has proven to be particularly true of the photographers coming from editorial and fashion environments.

This work seems to have most obviously blurred the distinctions between editorial-based and contemporary art-based filmmaking. Fashion and luxury goods, whose central message of brand communication is based on selling an aspiration and not a specific product, have fueled this area of practice, with a number of fashion photographers moving smoothly from their editorial-based narrative practice into sophisticated, conceptual advertising filmmaking.

# COMMERCIAL DESTINATIONS FOR THE MOVING IMAGE

An additional driver to the creation of this work is the need for these brands to promote their messages internationally via their websites. This need has resulted in large budget films that are only to be seen online being created by photographers as part of global campaigns that have their core within the traditional print media of the glossy fashion magazine. This combination of old school budgets and new school practice provides an interesting insight into the future for international brands.

Recognizing the power of the moving image and the fully integrated campaign, international brands are now seeing the aspirational film as an essential element of their commercial offering. This is the foundation of the concept of brand as a provider of engaging content, as a publisher, and as a creator of an engaged community. The new landscape of photography is simple to navigate if you understand this change in the client's perception and that the moving image is central to this new perception.

Global brands aren't the only companies that are recognizing the moving image as a powerful online commercial messaging tool. Where small budgets are all that is available, brands are placing the emphasis on creativity to achieve their goals. This is when the photographer/filmmaker is the obvious choice—based on budget and innovative thinking—for both creative and practical problem solving.

This new area of commissioning has led to a new genre of moving image being created. This is work that could never have been created without the ease and availability of DSLR digital filmmaking and editing technology. This genre can truly be described as moving image, a hybrid of creative influence, areas of practice, and new technology, which is the lifeblood of total creative convergence. Some of the most visually exciting and innovative work is being created in this genre, and it is developing its own areas of critical reference outside of the established rules and practices of filmmaking. Often criticized by filmmakers for its lack of substance, this genre of moving image may seem to have the nutritional value of spun sugar to some, but to others it is at the cutting edge of creative visualization and conceptual storytelling.

Meanwhile, photojournalists have seen the documentary as their natural home, many as a natural extension of the mixed-media practice previously mentioned. This has led to a rapid growth in the number of documentary films to be seen in film festivals, with some notable examples reaching the international and national arts cinema circuits.

Not surprisingly, the last five years have seen an impressive collection of films being produced by photographers and filmmakers about the subject they know most about and one that has been sadly neglected for too long, that of photography and iconic photographers. Films such as *Bill Cunningham's New York*, *In No Great Hurry: 13 Lessons in Life with Saul Leiter*, *Beneath the Roses: Gregory Crewdson*; and made for television films on Norman Parkinson, Vivienne Maier, David Bailey, Erwin Blumenfeld, Don McCullin, and Bert Stern, have brought a new understanding of photographers' work and the historical relevance of photography in the creative arts.

It is not just photographers who have captured the imagination of the new breed of documentary filmmaker, however. The ability to create films on micro budgets has ensured that filmmakers passionate enough to do so can now explore even the narrowest focused narrative. No subject is out of bounds for the documentary filmmaker, but in areas of conflict some of the most powerful, memorable, and moving pieces of work are being created.

# THE MOVING IMAGE REVOLUTION

In 2009 I was part of an event titled "Convergence," which took place at the National Film Theatre, London, and was instigated by the independent filmmaker and director Richard Jobson. Richard was an early pioneer of the possibilities that DSLR moving image functionality offered the established filmmaker. He was also passionate about showcasing the incredible work that a few early adopters of this new technology were creating.

There were one hundred photographers and filmmakers in the darkened cinema when Danfung Dennis showed his unedited rushes for a film he was working on titled *Battle for Hearts and Minds*. Danfung had been embedded in Afghanistan with the US Marines and had filmed them on operations with his Canon EOS 5D MKII strapped to his chest on a homemade metal frame. The sense of immediacy as he entered enemy positions with the Marines gave the audience the feeling that they were there. They were lifting the blanket in the hut unsure of what they would find—they had become that GI. The evidence of the power of the new way of seeing that DSLR moving image presented was clear for all present to see, and Danfung received an emotional standing ovation. Over the following years those rushes became part of the film *To Hell and Back*, which went on to win the World Cinema Jury Prize Documentary at the prestigious Sundance Film Festival in 2011, and was nominated for an Academy Award for Best Documentary in the same year. *To Hell and Back* has won over fourteen international film awards since it was first shown but at heart it is a film created by a photographer with a photographer's camera with a film and sound crew of one.

Photographer Danfung Dennis' multi-award winning *Hell and Back Again* was a solo project created while he was embedded with a US Marine company in Afghanistan. Filmed on a Canon EOS 5D MKII strapped to his chest on a homemade metal frame, its immediacy and raw graphic power demonstrated the new form of filmmaking language a DSLR offers.

What was first shown in a dark cinema in London in 2009 has become an industry norm. This recognition of the photojournalist as filmmaker was given further credence with the work of a photographer who was always open to converging media to tell his stories–Tim Hetherington. Hetherington also created his feature length documentary film, *Restrepo*, in Afghanistan while embedded with the US Marines. However, where Dennis's film is filled with raw emotion and intense physicality, Hetherington's film is quietly reflective with a brooding intensity born of a defined location of activity. *Restrepo* was the winner of the Grand Jury Prize Documentary at the Sundance Film Festival in 2010 and was also nominated for an Academy Award for Best Documentary in 2011.

What is interesting about *Restrepo* is that a book of still images created by Hetherington was published to coincide with the launch of the film. Hetherington saw the two platforms as being essential to telling the story of the soldiers with whom he spent so much time. He was an image-based storyteller who embraced whatever creative form was required to tell the story as he saw it. Despite the success of *Restrepo* he didn't stop capturing still images and he died on April 20, 2011, while covering the conflict in Libya. Hetherington and fellow photographer Chris Hondros were killed by Libyan forces in a mortar attack on the besieged city of Misrata.

**Tim Hetherington was a photographer who constantly looked to converging medias to help tell his powerful and intimate stories. *Restrepo* was a multi-award winning piece of work he completed before his death working as a photographer in Syria in 2011.**

Today, a large percentage of the news footage you see on television and online, particularly that created in conflict situations, has been created on DSLR cameras. The benefits of working with a small unobtrusive camera in such situations is obvious, but it has also come into its own in the confined and high-pressure situation of a commercial photographic shoot. The "behind-the-scenes" film has become a staple of both magazine websites and YouTube. This inside view of what it takes to photograph a model or celebrity—from arrival cappuccino through make-up, to shoot, to shoot wrap and inevitable group hug, high fives and whoops of delight—provides the perfect insight into the process of a high-energy shoot. It also allows the brand to portray a caring side to their product, "Of course we are your friend! Come and spend a day with us and find out what goes on!" This is the message that brands want to convey.

On the whole these films are successful in conveying this caring aspect despite their slightly formulaic structures, obvious choice of music, and relentless quick edits. They also provide the perfect opportunity for assistants to stretch their digital filmmaking wings as well as increasing their employability by being able to offer this service to more experienced photographers. However, there is rarely any budget for these shoots and the photographer will often be expected to provide a film as part of the stills shoot budget. It's a genre of moving image ripe for creative development and the work that appears on innovative image-maker Nick Knight's website, SHOWstudio, www.show studio.com, shows what can be done when the accepted rules are questioned and broken.

Knight established SHOWstudio in 2000 as an online destination to promote the moving image, which he saw as the perfect medium for the world of fashion in the digital age. Knight was ahead of his time, but as technology has caught up with his thinking SHOWstudio has been able to broadcast live from fashion shows and fashion shoots, stream live documentation of creative projects, and interact with its global community, while questioning and debating the very people who look to it as a recognized authority. SHOWstudio is a one-stop-shop answer to anyone who questions the possibilities that the moving image offers, created by and populated by photographers. It is further proof that the moving image has joined with photography across all areas of practice and been a key to the doors that divided different areas of practice. The doors are now open.

SHOWstudio was founded by photographer and filmmaker Nick Knight in November 2000 and is now the most important global platform for fashion and conceptual-based creative and innovative moving image work. Not only does it showcase new talent, it also allows established photographers to experiment with the moving image in both the creation and presentation of films.

## IT'S TIME TO INVEST

I think that it would be fair to say that photographers are not big spenders on equipment. Yes, the initial investment is considerable, but unlike the equipment-obsessed enthusiast we see our cameras and associated kit as tools to do a job. We want the best tools we can afford to last for as long as possible. Many of us even develop an emotional attachment to particular pieces of equipment and cling to it as we would a much-loved childhood toy, despite the logic of upgrading it. This is not an approach that can be brought to the world of the moving image. Your photography equipment may be good but the chances are that it is not going to be good enough for the world of digital filmmaking. It is a fact that initially you are going to have to spend more money than you probably have for quite some time.

The first item you are going to have to look at is your tripod. Shaky, hand held footage is not going to be accepted as professional work. So a solid and steady tripod with a fluid head (required for panning shots) is going to be your best filmmaking friend (although many photographers are working with monopods, a good tripod has to be the place to start). The tripod you use for stills may not deliver the stability that the moving image requires. However, the added stability is going to cost you up to three times as much as a tripod designed for stills. Despite the cost, a tripod and head specifically created for the moving image has to be your first major purchase.

# THE SOUNDSCAPE

Your next investments are going to be in an area in which you probably have little or no experience: the world of audio capture. Once you have overcome the fear of the moving image the fear of sound is just around the corner—waiting to strip you of your newfound filmmaking confidence. This is exactly why many photographers choose the easy solution of putting a piece of pre-recorded music to their images. If you are creating a music video that makes sense, if not it's a creative opportunity ignored and missed. Using your favorite piece of music may also create potential copyright infringement issues if you want to show your finished film to any form of audience, including an online one.

This book is not a "how to" manual—which I'm sure you have guessed by now—it is much more of a "why" manual with guidelines to best practice. However, when it comes to capturing audio you do need to establish a few fundamental principles before understanding what is possible and how to begin.

The first is that "bad sound can't be fixed." That oft heard comment "Fix it in post- . . ." does not apply to sound. You have to get it right at the source and that requires high quality recording equipment and great skill. However, it is possible to create imaginative and appropriate soundscapes with a basic understanding of what is required. Below are my five tips to help you get started and a list of the equipment you will need.

## How to Begin Capturing Audio

▼

1. Spend as much as you can afford on a directional microphone and try not to attach it to the camera unless you have absolutely no choice. You should expect to pay approximately $400 for an entry-level microphone.

2. Always record the ambient environment in which you are about to record before you start recording speech or specific sounds. This will be essential material when you are editing. Remember no place is ever totally silent.

3. Use a high quality portable recording device with built-in microphones to capture sound that you may use in a future project. Creating your own audio library is essential to learning about the potential of audio.

4. Invest in a good pair of headphones to monitor sound capture and editing.

5. Invest in a portable, HD recorder, monitor, and playback device.

As well as investing in an appropriate tripod and audio equipment there are a few other pieces of equipment you will need to get you started. You will need a supply of memory cards and a film editing software package. When it comes to basic editing, many photographers begin with Apple's iMovie as it comes bundled with most Macs. Despite its evolution you will find it limited in functionality and will inevitably want to move on to a more professional package. A few years ago this would have entailed moving onto Apple's Final Cut Pro. However, recent updates to the Pro X version have led many filmmakers and photographers to become dissatisfied with the direction Apple has taken. This has resulted in a large-scale adoption of Adobe's Premiere Pro and Avid as new industry standards. My advice is to look at all three, read forums, ask people working with the different programs, and determine which works best for you.

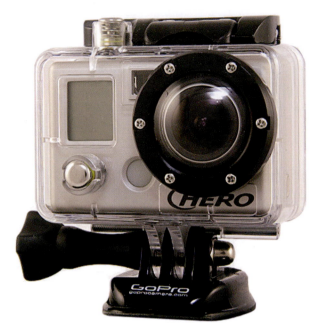

The HERO camera manufactured by GoPro brought about a revolution in the kind of moving image that could be created thanks to its high quality digital capture, small size, versatility, and robust construction.

# AVOIDING THE CLICHÉS, BEING REALISTIC, AND DELIVERING THE GOODS

I have already spoken about the formulaic clichés of the "behind-the-scenes" film, which many photographers have found themselves being asked to create. But that is not the only cliché approach to the moving image that photographers find themselves falling into. Perhaps the most prevalent and obvious genre, and one which fills many pages of both Vimeo and YouTube, is time-lapse photography. In itself it is a perfectly acceptable method of creating. However, time-lapse relies on subject matter being appropriate to the approach. Inevitably when so many time-lapse films are being created that is often not the case.

Creating time-lapse films is attractive to many photographers, as the amount of filmmaking input is minimal and there is a defined technique to follow. As such it is a great way to begin experimenting and a good way to introduce existing and potential clients to the idea of the moving image. However, it doesn't allow much scope to experiment outside of or within its format. For this reason I would always suggest that you do not allow your moving image to be defined by time-lapse, just as I would advise any photographer to be wary of techniques such as HDR and tilt and shift. When camera companies are building these in as pre-programmed creative effects—and they are—you know it's not a good idea to base your professional reputation on them.

Another genre of work that has swept through the world of moving image and greatly affected what we see in both big studio filmmaking and television programs has come from the world of extreme sports and action adventure. If the EOS Canon 5D MK II initiated a new landscape in the world of professional photography, the HERO camera did exactly the same for those passionately engaged with extreme sports. This tiny, tough, go anywhere camera not only produces television broadcast quality footage, it is also available at a price affordable to exactly the community at which it was aimed. That community wants to share their experiences and record their adventures and the HERO allows them to do just that, often from a point-of-view (POV) perspective with the HERO attached to their foreheads.

Such is the success of the HERO, thanks to the videos created with it that are posted on YouTube, that we have now become almost blasé about these extreme shots and near death experiences. They have become an essential element of both the blockbuster action movie and the aspirational action advertisement. The impossible to film has now become the everyday, created by the passionately engaged amateur and professional image-maker.

Just as with the world of photography, the world of moving image has many access points, and creative and commercial opportunities. You do not have to be—and should not try to be—the next Martin Scorsese or Steven Spielberg with your first experiments in the medium. If you do, you will soon become dispirited and overwhelmed by the complexity of creating a piece of scripted, acted, and directed filmmaking. Vimeo is filled with independently made surrealist horror films, dark and moody dramas, and intensely symbolic shorts. You do not need to add to these. You are a photographer coming to the moving image and not necessarily a budding filmmaker. As such your moving image work should

be an evolution of the established visual language of your still images. They should both be recognizably your work. They do not have to be seen as two completely separate areas of practice. They are not. So avoid the clichés, tell stories that are true to you, and use moving images to expand your visual aesthetic, not to reinvent it—unless it needs reinventing. As in all areas of early discovery, my advice is always the same, "K.I.S.S.—keep it simple stupid!"

# PRICING THE MOVING IMAGE

I commonly hear photographers proclaiming, and often read in ill-informed enthusiast photography magazines, that the main reason for engaging with the moving image is to make money.

Photographers are suffering a major economic downturn and have been for a number of years. I have already discussed the reasons for this and the actions I believe photographers need to take to refresh their professional practice. The addition of a new skill set and commercial offering has been greeted by many photographers as a career savior. One of the *raisons d'être* of this book is to identify ways and means by which photographers can survive both creatively and monetarily in the new landscape—moving image making has the potential to be both.

Even so, it would be a mistake to think, "If I'm doing more work, then I can charge more for it, right?" Wrong! Within the context of photography and commissioning this idea is unrealistic. Not impossible, but definitely unrealistic. A brief conversation with any locally-based filmmaker will soon enlighten you as to the fees and budgets within which they are expected to work. On a work-to-fee rationale skilled filmmakers are invariably working within smaller fees and budgets, in an increasingly overpopulated marketplace, than any photographer.

Changing your practice to that of a videographer is therefore not a guarantee of financial improvement. So the addition of the moving image to your practice will be exactly that, an addition. However, you will not necessarily be able to shoot stills and moving image on the same assignment at the same time, as both require specific creative mind-sets as well as technical considerations. The idea of making more money by offering moving image along with the commissioned stills on the same assignment is ill considered. What you will find, certainly on editorial-based assignments, is that the client will ask for both, on the same day but for the same fee! That is a reality that you will have to deal with, and having an assistant who can shoot moving image becomes a valuable commodity.

What you will find by shooting moving image is that you will have increased the possibility of being commissioned, and ultimately may receive commissions from clients with realistic moving image budgets in place. This may be as a filmmaker, a photographer, or, as is increasingly the case, on advertisement shoots as a director of photography (DOP or DP). The role of DOP is the ultimate test for a photographer used to being in total control of their image-making. The DOP does not handle the camera, pull focus, or set up lights they share their vision of the aesthetic and composition of the shots with the cameraman who then implements that vision. Some photographers feel energized by this way of working and others feel completely desolate, having lost control of the camera. It is the ultimate test of the photographer as team player.

So the moving image can create possibilities for your professional practice to grow and financial reward may come from that growth, but it is not to be embarked on purely to make more money, or to earn enough return to cover the substantial kit investment. As with all forms of business you have to be realistic about what your clients want and what they are willing to pay for your product. To assume that you can give them a new product that they may not know they need for a price you set, which is additional to their budget, is as ridiculous in reality as it appears here in print.

# FORMATS AND DELIVERY

The final stage of any moving image project is that of delivery to the client. Throughout this discussion, I have deliberately focused on the photographer coming to the moving image for the first time. I have, therefore, deliberately avoided tackling the complex world of filmmaking technology or language. There are more than enough good books and online forums where you can gain the information you will need as you progress through your projects.

However, there is one area on which I would like to give advice. This is on compression and file delivery. As photographers we are used to delivering our images to clients via FTP sites, e-mail, and file sharing packages, such as Dropbox and WeTransfer among others. We are also accustomed to creating the appropriate file sizes we need to deliver for the platform in which they are going to be used. However, when it comes to the moving image the files we create will be far greater in size than we are used to creating and delivering. The platform requirements will also be different from those we are used to. To add to this sense of ignorance and confusion, you cannot expect your client to know technical specifications of what they need either. So what do you do?

Well, the preferred format for the moving image is an H264 file, but it comes with a series of different wrappers and suffixes such as .mov, etc. Therefore, my advice is that you research what a H264 file is and how its different wrappers affect its size, format, and playability. That understanding will serve you well when it comes to understanding the right format in which to supply the work to your clients. Another good tip is to run your H264 file through a file converter to produce a low quality Windows Media File. H264 files can be viewed easily on a Mac but your client may have a PC. So send them both the H264 file and the Media File to ensure they can view the work you have produced for them.

However, the easiest way to transfer files and allow them to be seen is to use Vimeo as your transfer, store, view, and download option. By uploading your film to Vimeo it will automatically code your content and provide you with cloud storage. You can make any work you post private and give limited view and download access to your client. In many ways it is a one-stop-shop for the moving image novice, which is not seen as an amateur option. It solves a lot of client delivery problems and gives you the opportunity to promote work your client hasn't seen when they visit your page to download their film.

The new landscape of photography has been constructed from a wide array of tools, influenced by a combination of creative, technological, and economic factors and as such is a complex and ever shifting environment to both discuss and navigate. The most important tool in its construction, I believe, is the moving image. It has not only given the photographer new creative opportunities, it has also introduced the concept of collaboration with associated creative areas. It has allowed us to expand our storytelling into previously unaffordable sectors. It has challenged our willingness to explore and experiment with new media. The moving image has forced us to redefine the integral DNA of the twenty-first century photographer.

# TAKING CONTROL OF YOUR PROFESSIONAL PRACTICE

**TO BE ABLE TO TRAVERSE A** new landscape we require a map—a map that has been drawn with skill, accuracy, and knowledge. If you don't know how to get to your final destination, you will never reach it.

That map and landscape also require a compass to ensure that the direction in which you are traveling is the one in which you wish to travel. Simple concepts but worth reiterating in an environment in which there are so few signposts. Even more so in an environment in which it has become increasingly difficult to know not only how to get to your destination, but how to define what that destination is. The new landscape is still being drawn and built, it is not complete—it may never be—and it is still defining its own architectural language, its defined vernacular. These are times of continued commercial, technological, economic, political, and global change, and the foundations of this new landscape are built on shifting sands. This may appear to be an overly extended metaphor to describe the global environment in which the photographer finds him or herself living and working, but I truly believe that it is both accurate and required to bring understanding and resultant clarity to an environment of confusion and misinformation.

## CONSTRUCTING YOUR OWN LANDSCAPE

Each of us is in a position to build our own environment within the new landscape. We can choose which buildings we wish to construct, how they interconnect, whom we wish to invite into those buildings, and where we build them.

The process can best be described as "image-maker town planning" and an opportunity to construct a foundation for our careers as twenty-first century image-makers, and visual storytellers. The buildings we need to construct will have titles such as social media, moving image, online, personal work, clients, self-publishing, the print, stock, syndication, and so on and so on. The titles are up to each individual photographer to decide upon. We also have control over the creation of those buildings and what they are called. Nobody has to build all of them and nobody has to follow any order of construction or pre-ordained blueprint. The new landscape has no defined constitution. However, the buildings you do create need to be connected to each other and have a visual language that defines them as your property.

Of course, we all know that without people to populate them buildings are inanimate structures, just as without people to bring them to life software packages are merely code, and without the photographer to compose an image digital photography remains just a digital process.

We are the people who bring these inanimate objects and concepts to life. Therefore, just as the landscape in which we need to exist has changed so must our essential DNA. Our basic make-up has to change in order to meet the demands being placed upon us as professional photographers.

# DEFINE YOUR PHOTOGRAPHIC DNA

In extremely basic terms your DNA defines what color your eyes are, how tall you are, whether you have a lot of body hair—everything and anything that makes you who you are is dependent on your DNA. Since the birth of photography and before the digital revolution at the beginning of this century, the photographer's DNA has remained remarkably stable. The basic structure of that DNA required visual creativity, inquisitiveness about your environment (on both a micro and macro level), and photographic technical knowledge. That was it! All other properties, which combined to define what type of photographer you were, the genres you worked in, and how you constructed your career, were outside of the basic requirements of the photographer. This is no longer the case.

# WHO AM I? AND WHAT DO I KNOW?

These are questions that I regularly suggest photographers ask themselves. Why? Because it is too easy to fall into the belief trap that experience leads to all consuming knowledge. The following statement may sound very familiar to many of you, "I've been working as a professional for twenty-five years, and I know how the industry works!" Well, I'm sorry but you don't if that knowledge is based on experiences gained at the beginning of that career.

The new landscape demands both an open mind to new ideas, experiences, and opinions as well as willingness to adopt and evolve new strategies and possibilities. For many these concepts are challenging and unwelcome. They shake up the accepted, and question the established procedures and standpoints that have brought both creative and financial success. However, many photographers have seen their secure, established photographic business models crumble and fail. For these people, what I am saying will come as no surprise. They have realized that things have changed and that they are going to have to change with them. The big question is how?

## YOU NEED A PHOTOGRAPHIC MAP AND COMPASS

This is where an essential map and compass have been missing. Many photographers adapted well to the digital revolution. They embraced the possibilities and made hay, while others felt overwhelmed by the same possibilities and found they were clinging to a rapidly non-relevant past—since that time many have been playing catch-up. From a personal perspective it was sad to see photographers so derailed by the new commercial environments in which they found themselves. I, like them, was trying to find my own understanding of what was happening and where photography was headed. It was at this time, as many photographers looked for the answers, a major misunderstanding of what was going to be required took place.

The search for answers became the search for a photographic holy grail with many people eager to provide their own version of this mythical object. I believe this search to have been—and to still be—fruitless. There is no one answer that is appropriate for all photographers and it is certainly the case that all photographers do not have to embrace and do everything to survive. However, the panic of an uncertain future can often see people cling to the nearest lifeboat, even if it has a number of big holes in it. What I know today is that the tools are now available to us—either for free or for very little cost—to develop individually focused solutions that combine to create foundations for a potentially successful and evolved career in image-making. To completely misquote *Star Trek's* Mr. Spock "It's life Jim but not as we knew it."

# DEFINE YOUR ARCHITECTURE

When I first became involved in the design and construction of websites as I have pre-viously mentioned, the talk was of web architecture, the basis of which was to develop websites that presented the user with a satisfying experience, where they could access the information they wanted with as few clicks as possible. That premise remains as important today as it did then, I just don't hear it being spoken about these days. If you take the term web architecture and expand it to encompass all areas of your photo-graphic practice, then the concept of the new landscape being populated by your own architectural vernacular makes complete sense. And like all good architecture, yours will have to be built to perform the functions required by the people who are going to use it—your existing and potential client base and engaged community.

Your online personality will develop from your actual personality and the visual language of your images. This will be who you are. What you know will be dictated by your level of openness and appetite for research and learning. The understanding of these two elements will lead you to the correct conclusions, which will allow you to construct the buildings you need to connect to each other. The answers will come from the work—not from another photographer or so-called expert. My role is to make you aware of what is available and what is generally considered to be best practice; but only you can decide what is right for you.

Before you begin constructing your own architecture, be aware of a trap that is particu-larly easy to fall into. The term "busy fool" is one I have used previously. It has never been more appropriate than it is today for many photographers who spend their days build-ing their architecture, engaging in social media, and repeatedly reworking existing work without a true understanding of what the finished outcome should and will be. Time is spent but no income is achieved, the computer screen becomes a friend, and the fear of actual client engagement becomes a paralyzing reality. If this sounds like you, stop imme-diately and ask yourself the two questions I ask myself each day. Who am I? And what do I know? It may be tough to do initially, but given time you will find yourself re-energized and on the right road across the new landscape.

With a few notable exceptions, commissioners within the photographic world have been a historically conservative brotherhood. The new landscaper has seen this situation turned on its head. One turn-around has been the increasing number of women becoming a

force in all areas of the photographic community, including as photographers, commissioners, educators, and curators. The new landscape is being developed by a democratic community in which women are a powerful force and this has had a positive impact not only on the work being produced but also how the community communicates within and outside its established frontiers.

# NEW BUILDINGS

So far I have discussed and explained the premise of the new landscape and how I see it as the photographer's responsibility to populate that landscape with buildings of their own construction. I believe that the idea of using the word "building" to describe the various digital and offline platforms you need to create frees the photographer from seeing the multiple options available as non-related choices. They are not; by seeing them as various singular chores to be completed you will prevent yourself from using them to their maximum effect. The building of context for these new opportunities for your professional practice is not only important, it is essential. Without it misunderstandings occur, not only because of a lack of understanding, but also because of preconceived understandings of language.

# WHAT DEFINES A PROFESSIONAL PHOTOGRAPHER?

I was recently asked to give a talk about the subjects contained within this book to an audience of photographers and those involved with photographic education as part of a three-day conference. My talk was to be on the final day but I attended all three days to hear what the other speakers had to say.

One particularly learned speaker spoke with a disturbing lack of passion about the importance of the contemporary art photography market, stressing the importance of the work being created based upon the deconstruction of the photographic image, with no mention of the reality of commerce or of the other genres of professional practice. This caused a comment to be made concerning the constant battle between "art" and "commercial" photography. The comment was dismissed and I felt myself compelled

to state—as I have earlier in this book—that from my perspective photography without a client is a hobby. The room erupted and the speaker responded both aggressively and with indignation. Her response was due to her negative interpretation of both of these words, "client" and "hobby." She saw the word "client" as a dirty word, which should have no place in the creation of art, and the word "hobby" as a description of photography as nothing more than an enthusiast's pastime.

The truth of professional photography is that if you are not paid for your work then, yes, it is a hobby, as you will need to earn your living from some other activity. Therefore the client is the enabler who allows you to both pay your bills and continue with your photographic practice. To try and remove contemporary fine art from this equation is patently ridiculous when the photographs that sell for the highest value, do so in that very market. In fact, it could be argued that contemporary art photography is totally dependent on the client, the enabler, and the patron, and has been since the earliest days of creative practice. All professional photographers have client bases in different forms and should have no problem with the word; it is interesting that the use of these two simple words should create such anger and resentment. In my personal photographic architecture I have a building named "Clients" and it is the one that I spend the most time in and on.

The use of the word "hobby" hits at the heart of the many fears and worries photographers are dealing with today. Photography is a hobby for many enthusiasts, and it can be a richly rewarding one. For these people photography is a subject they passionately engage with without hope of financial return. In that sense, the hobby is a noble activity and not one to be dismissed as being lesser than any other engagement with photographic practice. The problem for the professional photographer is that technology is allowing those enthusiast/hobbyists to have a better "hit" and quality rate, and their work is crossing over into the professional arena—from weddings to stock, from news to traditional below-the-line advertising. Consequently, many professional photographers see the enthusiast photographer as a threat to their careers. This may or may not be true. Rather than focusing on the negative aspects of this situation, I propose that we create a building named "Enthusiast," and ensure that all our other buildings have a defined architectural vernacular different from anything that happens in that building.

On my way out of the auditorium a number of audience members came up to me and congratulated me on both my comments and my courage voicing them. I explained that I had not made the comments expecting such a vitriolic response.

On the final day I gave my talk and explained how I see the terms "client" and "hobby" within the context of buildings and the new landscape. The response was positive to both the thinking and the clarity that the development of a new accuracy of language can bring. I left the conference happy and wiser. Happy that many of the attendees had grasped the concepts I was sharing, and wiser that, even though many of us feel that we are traversing the new landscape smoothly, there are those still fearful of what that journey may bring. I believe that the concept of new buildings not only reduces those fears it also gives the photographer the power to shape their own environment and destination, by re-defining their understanding of the language used to describe the touch points they have with the wider photography community.

At the same conference a world-renowned contemporary art photographer spoke of how he felt that the work he is best known for creating feels inappropriate to the times we live in. He explained that it felt too controlled and formulaic. This revelation had come to him from working with young photographers and seeing how they used photography to record the minutiae of their lives, how they used smartphones to create images, and how they were open to images happening spontaneously and not having to be controlled.

This photographer's work is sold through major galleries and auction houses for tens of thousands of dollars, and exhibited in national museums. And yet he was sufficiently open-minded to see that things have changed and energized enough to change with those times. Interestingly when questioned on the subject of clients, he answered that his work exists within the contemporary art market and that he enters and wins competitions as well as being commissioned by magazines and advertising agencies. Further proof that the new landscape is not merely a theoretical concept; it is here—and it is here to stay.

## NEW COMMUNITIES AND WHO DO I KNOW?

Perhaps the most obvious indicators of the rise of the new photographic communities are the proliferation over the past few years of photography and filmmaking talks, events, and festivals. These have grown in company with the burgeoning online communities; spaces where photographers and filmmakers have been able to share their passions, knowledge, thoughts, opinions, and advice with fellow creatives on a global network

The new photographic community has embraced the online environment to build communities and communicate with like-minded people. It has also used it as a marketing tool to promote events, exhibitions, and regular meetings. Many of these groups are created by passionate photographers without funding and they rely upon each other to be supportive and open, marketing other groups' events to their communities.

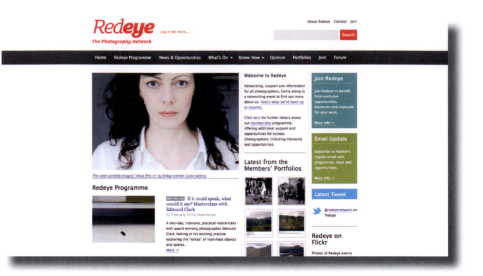

# — The Miniclick Photography Talks

all of the goings on with the Miniclick Photography Talks

Home / About / Publication#2 / Satellite Gallery / Upcoming Events

Search

### Our Diary

Featured
—
Jim Stephenson, Lou Miller
—
Leave a Comment

### What's Coming Up

Sound & Vision /
on The Miniclick
Talks

# MINI CLICK

Welcome! This is your one stop shop to find out all about the events the Miniclick Photography Talks have planned for the future. For more info, click "About" from the menu above. In the meantime, here's what we have coming up (click each event for all the info)…

*Monday 02nd December / Dukes at Komedia, Brighton / "Which Way is the Front Line from Here? The Life and Time of Tim Hetherington" Film Screening.*

**The Photobook**
**Advent Calendar –**
This year, in the true spirit of Christmas, we're doing the Miniclick Photobook Advent Calendar where we'll look at a different photobook, newspaper, magazine or 'zine we like by someone we've worked

About ICP   Support ICP   Press Room   Community   Newsletter

International Center of Photography

VISIT   MUSEUM   SCHOOL   RESEARCH CENTER   EVENTS   MEMBERSHIP   STORE

Home

## ICP LECTURE SERIES

ICP launched *The ICP lecture series* in the spring of 1974 to provide a forum for distinguished photographers to present their work and discuss their ideas and techniques with an audience of professionals, students, and dedicated amateurs, all of whom share a deep interest in photography.

The series is a public program open to ICP, giving audiences both within and outside the photography world an opportunity to learn from professional photographers firsthand, and to engage speakers in an often spirited question-and-answer session that provides additional opportunities to extend their technical experience, aesthetic sensibilities, and glean behind-the-scenes information on the careers and working habits of successful photographers. Speakers in the series represent the wide range of photographic expression, from photojournalism to fashion to art.

**FALL PROGRAM**   **ARCHIVE**   **LIVE STREAMING**

Contact us for more information.

*The ICP Lecture Series is made possible by Duggal Visual Solutions, The Bernard Lee Schwartz Foundation, Inc., and by public funds from the New York City Department of Cultural Affairs in partnership with the City Council.*

NYCULTURE   DUGGAL VISUAL SOLUTIONS

Home   About   Location   Contact                Search

PHOTO FORUM

### ABOUT

#### December

It's been a great year for Photo-Forum with some brilliant speakers and really good audiences. And the pub eat/drink/natter sessions have been pretty good too!

With Christmas being such a busy time we've decided that we'll not hold the planned party and exhibition after all. There are two other interesting events on the same night - the MA photojournalism & documentary show at LCC and the members show at Photofusion. We don't want to split the audiences unnecessarily so why not come along to one of these? That's what the PF team will be doing!

Talks are held on the second Thursday each month 6pm - 8pm. They are FREE and first come - first seated. Come and connect with fellow working photographers.

Photo-Forum is an independent group run by photographers for photographers. We encourage constructive questions, debate and discussion.

Location - Calumet, 93-103 Drummond St, London NW1 2HU View Map Our grateful thanks go to Calumet for their generous loan of the room.

of forums: Facebook, podcasts, Twitter, blogs, and websites. The best of these online communities see themselves as centers for not-for-profit information and image sharing; mutually supportive networks that allow photographers to have a voice and an outlet for their work and opinions. From a global perspective these communities have opened up the photographic debate to territories that were previously excluded. The global shared experience is now open to all. Yet it would be a mistake to see online platforms as being the only points of connection within the new communities.

The traditional analog meeting points provided by the commercial darkroom, magazine office, and advertising studio have been replaced by the online platforms, but the need for personal interaction has not been lost. If anything it has been accelerated by the limitations and possibilities of the online process. The limitations are obvious: a limited character count, the lack of expression and emotion in a typewritten post, and the lack of physical contact are all aspects that leave any online interaction wanting. The possibilities are also obvious: the opportunity to build a similarly engaged community, to promote events to that community, and to develop an online personality that is complimentary to who you are and how you want to be seen.

The limitations of this form of interaction have promoted the new communities' desire to meet in person; the platforms have made those meetings possible on both a micro and macro scale. Be aware, however, that the new communities have rules and regulations of behavior; there is an unwritten etiquette of interaction, which needs to be observed. But it is no different from that which is expected in everyday life. Successful interaction is based upon mutual respect of both work and opinions; it is not based upon arrogance or misplaced aggressive self-promotion. With these basic rules understood, the way in which you create your own community, who you want to be part of it, and how you use the information of who is within that community present some interesting points for discussion. I recently read an article written by a leading figure within an international non-government organization (NGO) responsible for commissioning a considerable number of photographers each year to work in the field. In the article he suggested that photographers had to create communities; well I was with him on that. He then went on to suggest that those communities should include people who were important to potential commissioners. His reasoning for this was that the photographers should use this information to promote themselves to NGOs that would then be eager to "buy in" to a community with the aim of using the photographers community as a new audience for the NGO's message.

This appropriation of the photographers' community raises all manner of issues concerning why people have chosen to follow you on whichever platforms you exist. It also confuses what should be a direct and honest relationship with your online community based on your online personality, and not the corporate personality of the NGO, over which you have no control. It also suggests that the more prestigious the people within your community, the more value you have as a photographer to the NGO. In turn, it could therefore be argued that the building of your community should be based on this premise. To do so would be a mistake.

Your community would quickly see through such a cynical approach and the commercialization of their interest in you and your work. An engaged audience is a sophisticated and attuned audience that cannot easily be fooled, so beware of attempting to use your community for your own advantage; an online backlash can be cruel and travel at incredible pace. Integrity is key to all areas of photographic practice and once lost it is extremely hard to regain, so don't be tempted to lose it!

# THE LONELINESS OF THE LONG DISTANCE PROFESSIONAL PHOTOGRAPHER

I once wrote an article titled "The Loneliness of the Long Distance Professional Photographer" for a photographic magazine. The title was a re-working of the classic 1960s film titled *The Loneliness of the Long Distance Runner,* a film based on a short story in which a teenager who faces a life of petty crime turns to long distance running as a method of both emotional and physical escape. This seemed to me an appropriate parallel to the position in which many photographers find themselves. They are trapped by the computer screen, working in an isolated situation, and desperate for human interaction with like-minded people. The article dealt with the resulting depression that can set in if this situation is allowed to continue, and looked at the history of suicide within the photographic community by examining the deaths of noted photographers: Diane Arbus, Terence Donovan, and Bob Carlos Clarke. The response to the article was incredible and the magazine was inundated with letters and e-mails praising its bravery for publishing the piece.

Today that loneliness does not have to consume the independent photographer thanks to the newly established communities that you are now able to engage with. The life of a photographer is a shared experience and it has never been easier to share your experiences. You will quickly find that not only will you be interested in what other photographers have to say but they will also be interested in what you have to say. In this sense friendships and communities are swiftly created.

As photography has become a global commissioning market the intense local rivalry that previously hampered the social interaction of photographers who could both be pitching for the same job has been removed. We are now in a very big boat and we need to be supportive of each other to ensure that it doesn't sink. I believe that responsibility lies with the individual and the new communities that have formed, not with the established professional bodies and associations, many of which are struggling to understand the realities of the new landscape. Their problem is that they are tied to outdated practices and beliefs, which by their very nature prevent them from accepting new practices, which in turn jeopardize the foundation on which they have been built. This leaves them feeling frightened and confused, unable to support their members in the way that they need to be supported, and unable to move forward. In reality their futures will be short unless they adapt to the new landscape and focus on the issues they and many of their members want to avoid.

# NEW POSSIBILITIES

I have spent much of this book talking about new possibilities, many of which have been created thanks to technological advancements. But just as it is a mistake to perceive new communities as only being online communities, the same mistake should not be made about new possibilities that the new landscape offers. The technological advancements are merely enablers that offer a series of possibilities for us to develop our creativity and build our roles within the photographic community. They are not ends in themselves. It's important to keep reminding ourselves of this as I repeatedly hear photographers telling me that various platforms do not work, or that they don't understand the relevance of them to their lives.

The relevance is simple: they allow you to promote, experiment, and communicate. The point about them not working is invariably based on lack of both commitment and understanding. These qualities are old fashioned in their implementation; it's only the tools that are new. It is by seeing these software packages and online platforms as nothing more than tools that we can see the possibilities they are creating. Put simply, they now allow us to do more and to keep our costs down. Therefore the possibilities are endless, just as our imaginations are endless and person specific.

The most important consideration when deciding where you want to go with your image-making is interconnectivity. No man is an island and no platform exists without reference to another, which once again emphasizes the importance of a photographic architecture. However, if you find the opportunities and possibilities facing you—or the concepts I am outlining—overwhelming, a simple task should help you focus on those open to you, their appropriateness, and their potential to be mutually supportive across your photographic practice.

First, take a large sheet of white paper, minimum A3 in size, and a broad black marker pen, such as a Sharpie. In the center of the sheet of paper write down the name of the project on which you want to work—this may be an individual piece of personal work, the type of work with which you are engaged, or a genre of photography—then draw a large circle around what you have written leaving space for other circles to be drawn around it. What you are doing is creating a knowledge map. If we return to the metaphor of building a new town within the new landscape, we have just created our central town square, or plaza.

You then need to decide what you feel is important for you to add to this central concept: for example, a website, blog, social media, etc. These are the main buildings that are going to face onto the town square. Some of them may overlap, as people would visit more than one building as they would in an actual town. Draw circles around the names you have given your buildings. Some of these will create overlapping intersections, where it is possible for two communities to meet. These intersections will start to suggest possibilities of engagement. Around the buildings on the main square you should add more specific buildings: for example, Facebook, Twitter, and LinkedIn would all be placed around Social Media—but they would not have large areas of intersection as people often remain faithful to only one of these platforms. However, all of them would connect with live events, as they are all good ways to promote and market live interactions. Facebook

is a good driver of online traffic to your website so that is an obvious intersection—but it is not as strong a driver as Google so that interaction will be greater. By the time you have completed your drawing you should be able to see what possibilities are open to you and which ones you should focus most of your attention on, both financially and in time spent. These may include workshops, talks, self-publishing, and all forms of offline activity, but what will be important for you to understand is how online activity will enable those activities to succeed and vice versa. What is important is to not be dictated to by the new landscape, but to learn the new rules and play by them—take it on and make it work to your advantage. When the ball starts rolling it is sometimes difficult to control but the momentum you create is the one you need for your career to progress.

It is natural to see the concept of new possibilities as being of relevance to you as a photographer. But it is also true to say that the images you create are now in a position to take advantage of the new possibilities open to them.

An example of what your own knowledge map could look like.

The online environment allows an image to live a life of its own, with little or no input from the person who created it. The negative aspects of this are often reported and discussed. I recently heard from a photographer facing high-powered Hollywood lawyers, unhappy that an image he had taken of a Hollywood star had gone viral thanks to his posting of a portrait of the actor on his website. The photographer had been within his rights to do so, he had signed no copyright agreement when he accepted the editorial commission and he had followed the universally accepted protocol of a photographer in his position. However, what he did not know was that the commissioning publication had signed a copyright agreement on his behalf without his knowledge—yes, this can happen and, yes, it can be legally binding. Someone had then taken his image and photoshopped it onto an image from the set of the star's forthcoming film. Suffice to say the photographer suffered many sleepless nights before a mutually agreeable settlement was reached.

That's the negative but what about the positive? To accept the uncontrolled life of an image requires the photographer to adopt a new relationship with the images they create. First there has to be an acceptance that the images you create now have more than one role, once you place them in the online world. The use of a Creative Commons license can give you a level of control by placing defined usage criteria with which you feel comfortable. But before you even get to this stage you will have to accept that your images are now not only a potential money earner, they are also an extremely powerful marketing tool.

In fact, your images are the most important factor in the growth of your photographic process in the new landscape. Photographers have always been judged on their work; the difference now is that your work will not only be promoted by you, it will be promoted by everyone who likes your images and chooses to blog and re-blog them, post them on their Facebook page, and tweet links to your site. With correct attribution to your images, your profile will be raised and people you didn't even know existed will see your images on a global perspective. Your images will create new possibilities for you without your knowledge or input. I know that this is a great leap of faith for many photographers—fearful of the negative experiences we hear so much about—but as with so many aspects of the new landscape, if we do not respond and adapt to its climate we will be left behind by those willing to take the necessary risks to succeed.

The possibilities I have discussed so far have been based on the photographer's primary practice of creating images. However, as with the creation of audio for the moving image, the new landscape gives you possibilities to expand into areas that you may have previously not considered open to you. An excellent example of this is the podcast: a simple to create piece of broadcast content that allows you to engage with fellow creatives, while also promoting your own practice, which when placed onto iTunes becomes a radio broadcast. Similarly by creating a YouTube or Vimeo channel you are opening up the possibilities for your own television channel. Just as the intrinsic skills of the photographer can allow you to become an informed and influential publisher, so those same skills and knowledge can lead you into becoming a broadcaster. If used correctly and with commitment, both of these new opportunities can open up a global audience for you to become an informed commentator, an expert, and someone to take seriously. These online platforms and roles can then lead to developing this position as an informed commentator into off-line workshops and talks, in effect taking your experience and knowledge and using them for the purpose of education. It is this form of connected and linear thinking that will take your primary practice into new environments and new economies.

**There is no shortage of free photographic podcasts you can listen to on iTunes. They are easy to produce and free to post so why not consider creating your own?**

# NEW ECONOMIES

To discuss the new economies that have impacted on the role of the photographer, we first have to accept the nature of the client, or enabler. We need someone to reward us for our work to ensure that we can describe ourselves as photographers—to see photography as our main profession. I know that this may seem like stating the obvious but there are some still unwilling to accept the commercialization of photography, as if the commissioned image is of less value than the self-initiated image. This is a concept that I cannot accept. Overcoming this hurdle of misunderstanding is the first step in accepting the financial opportunities that the new landscape presents.

There is no more common subject of conversation among photographers than the state of the photographic economy. Fees are lower than they have ever been, budgets smaller than ever, stock photography rates greatly reduced, and the digital workflow has removed most of the "added extras" that allowed photographers to "bump-up" their final invoices. The opportunities to travel are fewer, the editorial environment is in turmoil, and competition for work has never been greater. These are just facts that we have to face. However, there are new economies that represent a positive future for the established and potential photographer, but before we discuss them I would like to share a conversation I had with a young photographer coming to the end of his formal photographic education.

The photographer in question was writing a dissertation based on the premise that photography is currently in a state of terminal collapse due to the fact that magazines are no longer providing the platform they once did for photojournalism. He went on to proclaim that it had never been harder to see what he described as "good" work.

He had formulated his belief on the basis of a photo education he had received from people whose experiences and knowledge had been largely formulated nearly twenty years prior. I immediately felt the need to turn his pessimism into optimism; it was an understanding of the new economies that underpinned my process of conversion. The truth is that it is not photography that is in a state of decline, it is magazine and newspaper publishing. The publishing model of revenue creation, content creation, and distribution has evolved but changed little since the invention of the commercial printing press and its success has been based on the fact that it has traditionally been a main principle of mass communication. As such it set the rules and we had to play by them. Advertisers paid the publishers' page rates, distributors stocked the product, and we purchased the

product; all of which were controlled by the publisher. The advent of radio and television impacted this established relationship we had with the printed page, but they were alternative forms of interaction, they were not replacements. The advent of the online environment is a potential replacement for all three—print, radio, and television—and that changes everything.

The photographer's comment that he finds it difficult to find what he considered "good" work is perhaps an even stronger indicator of the "old thinking" that can affect a photographer's perception of the current image-making environment. It has never been easier to see work, good or bad, either on or off-line. In fact it is difficult to avoid work as every photographer tries to make themselves heard among the cacophony of digital imagery with which we are being bombarded on an hour-by-hour basis.

But his comment concerned "good" work. So how do you find that? And is it really hard to find? I would argue that it is not hard to find if you know where to look. And to find out where to look you need to be engaged with the new landscape. You need to follow the right people, publications, museums, and galleries on Twitter; you need to be inquisitive and willing to find out who's doing what, where, how, and why. All of this is now easy to do. It does, however, require a willingness to do so. Was it easier in the "golden days" that the young photographer yearns for? No. In London until the birth of the online environment, only three bookshops sold photography books, and weekly visits to those shops were required to find out what was new. Only three galleries focused on photography—all other information about what photographers were doing was reliant on word-of-mouth communication. Today we can access great work at the click of a mouse, if we know where to point our cursor.

A commonly heard phrase, oft repeated by photographers, with which I am sure you are familiar, is: "We are all photographers now." I cannot disagree with this assumption because it is true that the majority of people now have access to cameras, if only via cell phones, and therefore to the creation of a photographic image. However, another statement that is just as relevant but less often repeated is: "We are all publishers now." Whereas many photographers perceive the first statement as a negative one, as if the democratization of their profession has caused the death of it, the second is positive as it proclaims that photographers are now in control of their own commercial destiny. This is the basis of the new economies.

The cult of the YouTuber is a phenomenon that has changed the way in which the current teenage generation engages with television and traditional editorial content. Live events such as Summer in the City 2013 in London, saw over twenty thousand teenagers attend a two-day event at which they could meet their YouTuber idols.

It is not the creation of images that has lost its power, but the platforms they appear on that has changed and therefore the way in which those images are used, perceived, and distributed. Rather than bemoaning the loss of the old platforms we must understand and populate the new ones. I have so far held off talking about the power of YouTube and the growth of the "YouTuber," but, as a new economy that demonstrates all of the elements that make up the new landscape as well as the base DNA of the digital native, it seems only right to address its structure at this point in our discussion. If what I am about to discuss comes as a revelation to you, you are most probably not still in your teenage years; if you are familiar with what I am about to say then you probably have teenage children or are engaged with the YouTube community in some way.

YouTubers are mostly in their teenage years, although some are now at universities and colleges. They are not trained filmmakers or broadcasters and yet that is exactly what they do. They are not trained journalists or storytellers and yet this is also what they do. They create editorial and broadcast content and present that content themselves, they are the stars of their own shows, and they are also their own filmmakers and production companies. They post short films on YouTube and receive millions of hits from their fellow digital natives. In return YouTube rewards them with advertising placement and the You-Tubers have become wealthy celebrities with agents promoting their live appearances at festivals around the globe. This is the new landscape in action and evidence of a new economy developing quickly with high financial returns.

What are the films they are creating that receive such huge international interest? They are short films based on established magazine and television broadcast ideas: how to do your make-up, how to decorate your bedroom, how to chat up girls. None of these editorial features will be new to those who have been brought up on magazines and traditional broadcast television—what is different is how they are being consumed. The films can be seen for free on YouTube, word-of-mouth recommendations via a "you might like this" panel grow the audience and both YouTube and Google provide the financial incentive. YouTubing embodies all of the qualities I have outlined within this book that I believe photographers need to understand to help them navigate the new landscape. While editorial commissions in magazines and newspapers dry up, that same content is flourishing on YouTube.

The YouTuber movement is similar to that of the punk/new wave movement of the late 1970s and early 1980s. Just as that movement destroyed the pomposity of overblown

musicianship and the corporate structure of the music industry, YouTubers are taking on and beating the publishing and broadcast establishments with a homemade approach and "can do" attitude.

The growth and success of these YouTube channels and YouTubers is directly relevant to the photographer in the new landscape. Not only are they producing the type of editorial content that was once the sole prerogative of the photographer, they are showing that that content has now moved on to a new platform and media. The moving image is now the appropriate medium for both and these are aspects that the photographer has to respond to positively.

The growth of the moving image as an appropriate medium for photographers to adopt as part of their practice, the growth of broadband width, and the re-establishment of brands within the new global digital economies are all key factors in the growth of the new photographic economies. But they are not the only factors. The premise of waiting for the phone to ring to be asked to take photographs for a client who will pay you an amount of money you consider reasonable is not dead. It still happens.

However, we have to accept that it happens less often and, when it does, it does so within a globally competitive marketplace. This marketplace is full of photographic traders shouting at the top of their voice for people to buy their wares. The clever trader in that marketplace understands what the potential client wants and how they are going to use what they are going to buy. A professional photographer is imbued with transferable skills and it is this awareness that will allow you to use them to best effect.

The cold reality of the new economies is that we have passed from being a commission dominant professional practice to one that is far more fluid. We can no longer expect all of our income to come from those asking us to provide a defined service in return for a defined financial return. We can no longer rely upon a middleman platform to distribute our images in return for what we consider to be an appropriate financial return. We can no longer expect to be the sole creative decision maker when working on commission. We can no longer expect people to find our work and us without making an effort to be found. We can no longer expect our images to be the sole provider of the context of our practice. All of these statements come with the caveat that there is always an exception that proves a rule. However, we can expect to be in control of our own destinies and context in myriad different ways.

# REQUIREMENTS AND EXPECTATIONS

"I am a photographer, I take photographs," that is and has always been the spine of any photographer's professional practice. But is that enough today? You may, of course, perceive that as being a rhetorical question based on what I have written so far in this book. But it is not. It's a challenge to any professional photographer to take up and address, no more or less than that. Only you will know if your answer to this question is convincing and honest.

Your answer will be based upon many factors, but one of the most important will be the expectation you have of your career and your photography. If you are meeting that expectation then I understand your reluctance to embrace change. However, I will have to question how long those expectations will continue to be met as the landscape continues to evolve.

If your answer to my challenge is that you recognize the need to expand your offering as a professional photographer, then you are in line with the majority of those commissioning. They feel that photographers need to expand their skill set because their expectations of photographers has changed and grown. It is vital to understand this mind-set—to not meet the expectation of someone commissioning you is career suicide.

I have written at length about the opportunities and possibilities that face the twenty-first century photographer. What I have written about may or may not have been news to you. My intention is not to be a bringer of revolutionary news but to provide an explanation that places that news in an understandable context. But just as I do not expect many of the possibilities to be news to you, they are also not news to those who work with photographers. People who commission work are now aware of the moving image, social media, exhibitions, podcasts, and post-production. They may not be fully informed about everything but they will expect you to be. They will expect you to be exploring the opportunities that the new environment brings and to be doing so passionately and with excitement.

Imagine the scene. You have an appointment to show your portfolio of work to a potential client who has responded to some form of contact you have made. These appointments are important and rare, so you are keen to make a good impression. You show your printed work, the client is impressed, and you engage in conversation about the possibility of being commissioned. The client asks you for your Twitter tag so that they can follow you. You don't have one and have to explain why not; they are on Twitter and you find yourself arguing against something they believe in.

They ask if you are experimenting with the moving image. You are not and have to explain why. They expect photographers to shoot moving image for their website and you find yourself arguing against what they do. This is a meeting that is going wrong, despite your work not because of it. It is your lack of engagement with the new landscape that they are part of that is making you harder and harder to commission. The client expects you to be engaged as they are and requires you to have a level of engagement similar to them. After all you are going to work together and you are going to create representations of their brand and be a representative of it. You both have to be on the same page!

This expectation should not just come from the client. It also needs to be a personal expectation if you wish to define yourself as a photographer within the environment of photography as a democratic practice open to all. Without engagement in the full spectrum that photographic practice now includes, how can you declare yourself to be a professional when judged against an enthusiast? You may answer, on the quality of your images—the better the photographer, the better the images—which to you is a judgment easy to make. But just as democracy has come to photography it has also come to the position of commissioner of photography. Your expectation of what you consider to be informed photographic judgment of your work may well be misplaced and not met, leaving you with someone judging you purely on images they may not be able to understand or place in any context. As a photographer you may say that this is as it should be and that it has always been this way. Well it hasn't, and it isn't. Your competitors are building other elements into their offerings that give different access points to their practice. These, in turn, encourage positive judgment on their suitability for commission by the less experienced photo commissioner, as much as by the jaded commissioner looking for something and someone "different."

This factor of expectation and requirement is best illustrated by the recent career of the photographer Peter Dench. Peter had an established career as a portrait and editorial photographer, begun in the early 1990s. He had won a number of awards and been represented by a prestigious agency until its closure. He was well known in the industry and his work was respected. However, by the mid-noughties his career had come to a standstill, he was in financial difficulties, and he found himself having to take on part-time temporary work in catering. His career as a full-time photographer was in jeopardy until he got a lucky break.

Familiar with his work, I had been reading his tweets, which were often dark and very personal. As the editor of a Photography magazine I was looking for someone to write a monthly diary that brought the reality of being a photographer to the reader. The photographer agreed on the basis that he had nothing to lose.

*The Diary of a Sometime Working Pro: The Dench Diary*, created by photographer Peter Dench, began life as a series of magazine columns before being published as an e-book and a pulp paperback novel. The diaries also encouraged Peter to create a series of short films.

The diary was an immediate hit and slowly but surely his profile grew based on the character he portrayed in his column. He posted the diary on his blog and promoted it through his Twitter feed and he experimented with the moving image to expand the reach of the diary. He came to the attention of a new gallery, who approached him to become their co-creative director; he used his growing audience to crowd fund a self-published book of his work; and finally he was taken on by an agency with global reach for commissions and syndication.

All of this took four years and now he is earning fees that a few years ago seemed impossible, his career is re-established, and he is once more a working photographer. The most interesting aspect of this whole story to me is that his photography never changed, only people's perception of him and what they believed they were buying into by being associated with him.

To me this story is inspiring and proof of what can be achieved with a positive attitude to the new landscape. It also shows how the barrier is being set by those willing to be open to what might be, rather than by being restrained by what was. Expectations and requirements are definitely coming from the client but they should also be coming from you, the photographer.

# A NEW COMPASS

The use of the word "compass," like all of the words I have used associated with the concept of the new landscape, is carefully chosen and, like many of the metaphors I have used throughout this book to make sense of the commercial world that faces professional photographers today, it may seem to be a strange choice with little association to the world of photography. But stay with me on this and I am sure that you will agree that it is the final piece in the jigsaw of understanding.

The question I am most often asked after I have spoken about my beliefs on the issues facing professional photographers today is this: "So, if all of that is true, where does that leave the professional photographer? And how are they going to make a living?" My answer is open-ended but always positive, and a continuation of the thought process I would have previously outlined. This is my answer.

Despite fears that the moving image will supersede the still image, I do not believe that this will be the case. However, I do believe that the role of still images and the photographers who create them has changed and will continue to change.

The photograph remains the most perfect process by which we can capture time, the fleeting moment, the decisive moment. As such its power is still highly relevant to our lives, but as I have previously outlined with the concept of the digital caveman, in the digital age it has a new power, that of being a universal language. Armed with the ability to create images with such power photographers should feel positive about their future. They are highly skilled communicators and storytellers whose time is now. The image has never been so relevant and powerful.

I am always nervous of any writer who cobbles together a series of quotes from well-known theorists to provide a convincing argument. I believe in placing an argument firmly within the realities that photographers face.

However, one man did foresee the situation we find ourselves in today and his words are relevant to the reality of the new landscape. In the early 1960s the cultural commentator and innovative thinker, Marshall McLuhan, wrote that the visual, individualistic print culture would soon be brought to an end by what he called "electronic interdependence": when electronic media replace visual culture with aural/oral culture. In this new age humankind will move from individualism and fragmentation to a collective identity, with a "tribal base." McLuhan's name for this new social organization was the "global village."

Though I have not based my understanding of the new landscape and how we need to approach it as a global environment on McLuhan's concept, it is interesting to see the parallels. These parallels are further seen in McLuhan's most widely known work *Understanding Media: The Extensions of Man*, published in 1964. It is a pioneering study in media theory that outlined his dismay at the way in which people approach and use new media such as television. McLuhan famously argued that in the modern world "We actually live mythically and integrally ... but we continue to think in the old, fragmented space and time patterns of the pre-electric age."

The parallels are clear as to how the move from analog to digital capture has seen so many people cling to their analog vernacular and language to bring understanding to new digital media. Don't panic, I am not about to delve into a series of paragraphs of intellectual theory that is both unintelligible and irrelevant to your current situation. However, I do think it is important to use McLuhan's insight, from more than fifty years ago, into the rise of global media to further emphasize that the changes we are going through as photographers need to be questioned and understood. They also require a new language. It is this new understanding and language that will allow us to become our own compass.

It is a natural human reaction to expect someone to show us the right way; it is an intrinsic foundation of our formal education. The teacher tells us what is correct; they have an established form of educating and follow pre-ordained rules. We learn from that teacher and implement what we have been taught to ensure that we are judged as being correct. This is old school teaching. It provides a foundation of knowledge but no impetus for creative independent thinking. The inspirational teacher will impart this same information with passion and encourage their students to not only understand the information they are being given, but also to question that information to gain understanding. They will vary the ways in which they impart information and set their own rules and agendas. If you are looking for someone who does not understand the new landscape of global photography to give you the correct answers, you are looking for the wrong kind of teacher. To be your own good compass you need to learn from the inspirational teacher—perhaps become one to others—and accept the responsibility of personal learning.

The new landscape requires creative independent thinking, it requires understanding, and it requires passion for what it offers. It also requires the photographer to redefine their role within that new landscape. We can no longer expect the term "photographer" as it is most widely understood based on historic fact to accurately explain and encapsulate the role of a professional photographer today.

We also cannot expect others to provide a new understanding of the role of the photographer in today's society. We need to provide that understanding. We need to redefine our role and our importance as image-makers not only for the world at large but also for ourselves. We need to reclaim the word "professional" and develop the understanding of the word "photographer." By doing this we will not only regain confidence in our chosen area of practice but we will also reposition the professional photographer in the global public's perception. Once this has been done the new role of the photographer in global communication will be both established and understood.

Returning to the three-day conference where I first put forward the concepts, ideas, and understanding I have of the new global landscape, I ended my presentation by suggesting that the audience should see themselves as a compass for the students they teach, that they must be the inspirational teachers. They are teaching the digital natives, those who have only known the new landscape. I mentioned this and was met with a sharp intake of breath. It is the same sharp intake of breath that any photographer with an established practice could make. Many of those educators saw the reality of what lay before them as being too daunting, others did not and that demographic of reaction provides the perfect microcosm of the global world of professional photography.

The current photographic community shares the demographic opinion and attitudes of that darkened conference auditorium. It is filled with the believers, non-believers, and the unaware. It is filled with knowledge, experience, and beliefs gained from a variety of sources. It is busy building bodies of work, client bases, and careers. It is paying bills, raising children, buying houses, and dealing with everyday life. In short it is busy and rarely finds the time to step back to consider the new landscape, to see the bigger picture, or how they fit into it.

It is understandable that this is the case and in many ways this has never been much of a problem. A profession that sets its own pace is easy to understand and to engage with. Today, however, our profession is no longer in a position to set its own pace, we are now dictated to by a spectrum of outside forces. It is for this reason that it is essential we take a moment to look outside of our immediate concerns and consider the concept of the new landscape.

I hope that you now feel ready to become fully engaged with the new landscape and that you understand how it was created, how you can be involved in its development, and how you can engage with it. How you can learn its language, create your own accent within that language, and travel successfully across its contours. I hope that you now feel that you have a map—even if it is one that is constantly being redrawn—to help you navigate your path and an understanding of the importance of being your own compass, at whatever stage you are in your photographic career. I have never been more excited or passionate about the world of photography and the possibilities that the new landscape offers in all areas of creative practice. I hope that you now share my excitement and passion.

# THE NEW LANDSCAPE COMMUNITY ONLINE

# RECOMMENDED PHOTOGRAPHERS' BLOGS AND WEBSITES

http://smalltowninertia.co.uk

http://terrysdiary.com

http://thedailychessum.com

http://theselby.com

http://www.chrisfloyd.com/blog

http://www.ewenspencer.com

http://www.martinparr.com/blog

www.littlebrownmushroom.com

www.peterdench.com

# INSPIRATIONAL AND USEFUL WEBSITES AND BLOGS

## General Photography

http://thephotographypost.com

http://prophotocoalition.com

http://www.2waylens.blogspot.co.uk

http://www.photoeye.com

http://www.wipnyc.org

http://www.newyorker.com/online/blogs/photobooth

http://photobookclub.org

www.showmepictures.co.uk

www.aphotoeditor.com

http://photofocus.com

www.bjp-online.com

www.pdnonline.com

http://www.americansuburbx.com

http://500photographers.blogspot.co.uk

http://unitednationsofphotography.com

http://flakphoto.com

http://japan-photo.info/blog

http://strobist.blogspot.co.uk

## Contemporary Art Photography

http://www.bigredandshiny.com

www.gupmagazine.com

http://www.acurator.com

http://www.huhmagazine.co.uk

http://www.1000wordsmag.com

http://actualcolorsmayvary.com

www.source.ie

http://vuucollective.com

http://daylightbooks.org

http://fractionmagazine.com

## Fashion Photography

http://fashionphotographyblog.com

http://www.thesartorialist.com

http://www.facehunter.org

http://runway.blogs.nytimes.com

http://fashion.telegraph.co.uk

http://www.fashionising.com/pictures

http://www.youtube.com/user/VogueTV#p/c/E66654AF8F5AC4B2

## Photojournalism and Social Documentary

www.foto8.com

www.worldpressphoto.org

http://lens.blogs.nytimes.com

http://blog.magnumphotos.com

http://photojournalismlinks.com

http://www.bagnewsnotes.com

http://blogs.nppa.org/visualstudent/

http://photocolumn.org

http://lpvmagazine.com

http://www.razoncollective.com/blog/

http://www.the37thframe.org

http://www.viistories.com

http://socialdocumentary.net

## Moving Image

www.newsshooter.com

http://showstudio.com

http://inmotion.magnumphotos.com

http://cinema.planet5d.com

www.thesmalls.com

www.festivalfocus.org

http://fstoppers.com

http://testmag.co.uk

http://philipbloom.net

www.laforetvisuals.com

www.fstopacademy.com

https://vimeo.com

www.nofilmschool.com

www.learningdslrvideo.com

www.prolost.com

www.hurlbutvisuals.com/blog

www.indietips.com

www.eoshd.com

www.redsharknews.com

http://kino-eye.com

http://cinescopophilia.com

http://thephotobook.wordpress.com

http://johnbrawley.wordpress.com

http://www.am-bruno.blogspot.co.uk

http://broken-spine.com

http://www.printfetish.com

## Theory

www.jmcolberg.com

www.david-campbell.org

www.phonar.covmedia.co.uk

www.picbod.covmedia.co.uk

http://eitherand.org

http://www.burnmagazine.org

http://www.afterphotography.org

http://theagnosticprint.org

## Self Publishing

http://theindependentphotobook.blogspot.co.uk

http://www.finddigitalmagazines.co.uk

http://buffet.andrew-phelps.com

http://www.mediabistro.com/galleycat

http://oneyearofbooks.tumblr.com

http://blog.photoeye.com

http://magculture.com

http://www.indiephotobooklibrary.org

http://bintphotobooks.blogspot.co.uk

http://www.selfpublishbehappy.com

http://www.isbn.nielsenbook.co.uk

http://www.magplus.com

http://www.selfpublishingreview.com

http://icplibrary.wordpress.com

http://www.publishandbedamned.org

http://abcoop.tumblr.com

http://www.booksonline.fr

# INDEX

Page numbers in *italics* refer to illustrations.

# ACKNOWLEDGEMENTS

I have many people to thank for helping me to build my understanding of the world of professional photography, past, present, and future, and I have tried to mention below as many as possible.

My first thank you is to every photographer I have ever worked with and a special thanks to those I have learnt most from: David Eustace, Jake Chessum, Jean Loup Sieff, Matthew Rolston, William Klein, Steve Pyke, John Swannell, Peter Dench, Julian Broad, Terry O'Neill, Sylvia Plachy, Corrine Day, Jim Mortram, and Gavin Evans.

My second is to all of the stylists, designers, editors, art directors, picture editors, and hair and make-up artists I have had the pleasure to work alongside, with special mention to Debi Angel, Clive Crook, Geoff Waring, Jane Proctor, and Kevin Aucoin.

My third is to those who have inspired and informed me, including Mr. Vincent, Gordon Crosby, Jonathan Worth, Jim Stephenson, W.M. Hunt, Jon Levy, Bruce Mclean, Robert Hughes, and of course, to Bob Dylan who introduced me to the power of words.

My fourth is to the students and my colleagues at the University of Gloucestershire, with special mention for their support and patience to Nick Sargeant, Trudie Ballantyne, and Matthew Murray.

Finally, a thank you to my editors at Focal Press, Kimberley Duncan-Mooney and Alison Duncan.